SMALL WORLD

A GLOBAL PHOTOGRAPHIC PROJECT

1987 – 1994

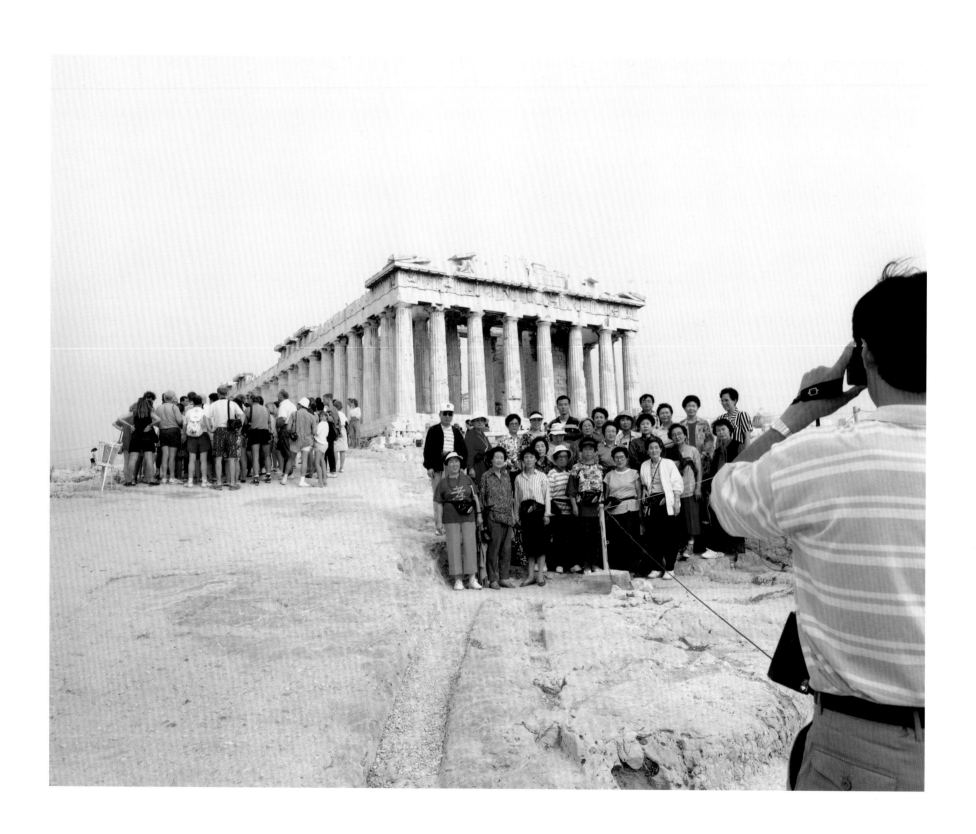

ACROPOLIS, ATHENS, GREECE

SMALL WORLD

MARTIN PARR

TEXT BY SIMON WINCHESTER

DEWI LEWIS
PUBLISHING

FIRST PUBLISHED IN THE UNITED KINGDOM IN 1995 BY

Dewi Lewis Publishing
8 Broomfield Road
Heaton Moor
Stockport SK4 4ND

0161 442 9450

ISBN: 1 899235 05 1

A CIP record for this book is available from the British Library

Distributed in the Netherlands by
De Verbeelding Booksellers Ltd
40 Utrechtsestraat
1017 VP Amsterdam
Tel: 20 626 53 85 Fax: 20 625 72 09

SMALL WORLD

SIMON WINCHESTER

Blaise Pascal, the 17th century French genius who blessed the world by inventing the hypodermic syringe and the calculating machine (if such things can be counted blessings) took a singular view of man's liking for travel. It was an ironic view, considering that he also invented the world's first public bus service: for so far as travel was concerned Pascal was, at least at first, implacably against it.

Tout le malheur des hommes, he wrote, *vient d'une seule chose, qui est de ne savoir pas demeurer en repos dans une chambre.* All the misfortunes of men derive from one single thing, which is *their inability to be at ease in a room at home.*

War and conquest and empire, all quite the thing in those days, most probably gave spur to his gloomy sentiment. During Pascal's short life – he died in 1662, at only 39 years old – the world was in a perplexing frenzy of what the Germans would eventually christen *wanderlust.* France was expanding on all sides, the British were colonising Africa, the Dutch were racing off to seek fortunes in the East Indies, settlers were warring with the natives in the Americas. Pascal's was a life played out against a backdrop of wandering and warfare, in which precious few men, it seems, were choosing to take his counsel and remain in the comfort of their living rooms, keeping the peace by their own firesides.

And yet how much more loudly would he have railed against the temper of today! Back in Pascal's day only a tiny number of men – and almost no women – were venturing onto the dangerous waters beyond their separate and familiar shores. By contrast today all humanity seems to be gripped by a fervour of movement. Man appears seized by a goading restlessness, to be caught up in a strange psychic phenomenon that requires everyone to want to be wherever he or she is not.

Of course there are, and long have been, many reasons why anyone might wish or might be compelled to be away from home; but what is happening today is very different. Never before in human history have all those reasons conspired with one another to create so vast an ebb and flow of humankind. Beforehand the reasons would act one at a time – this century was one of war, that era was one of exploring, those were times of mass migration. But nowadays they seem to be acting in some kind of spontaneous and disharmonious concert – most probably because, for the first time ever, those who want to move have the ability, with planes and trains and automobiles, to do so at will and with relative ease. The result is a mankind that is currently trapped, if trapped be the word, in some kind of globe-shrinking perpetual motion.

Travel, in terms both of money spent and people employed, is now the second biggest business in the world, after agriculture. And the statisticians are certain: soon after the new century begins travel will become the biggest business of all. Someone wrote recently that if tourism were a country – and tourism is just one component of our peripatetic urge – then it would be the third largest nation on the planet.

Hundreds of millions of people are these days moving, ever moving, as if life itself were somehow not journey enough for them. The state of man that was at one time contemplative, monastic and pastoral is now frantic, breathless, enslaved to time and to ambition, guided and directed by the demands of machinery and technology. We once had such high hopes for all this technology – that it would free us from drudgery, open up more time for our peace, amusement and pleasure. And yet it hasn't worked like that at all. The marvellous machines have not succeeded in making us any more leisured nor our lives any more leisurely. The peace we crave and which we always think we'll find seems to perpetually elude us.

We don't have this peace at home, at work, or with our families – and are currently transfixed instead by the idea that we may find it somewhere far away. It is an irony of our small, and ever-shrinking world, that one of our primary travelling urges today is this need to find the very contemplative serenity that we have lost from times before. And we travel ever-harder, ever further, in our desperation to find it.

So we board our jumbo-jets precisely to find a world where there are no jumbo-jets. We pass through security to get to a land where there is no more a need to do so. We look for elysium in distant islands where there are no hamburger stands and satellite dishes and telephones – and yet all the while men have come before us and built and installed precisely those things that we were hoping to get away from, and have made where we are going just a little more like where we have just come from. So in eternally frustrated hope that somewhere, some God-given somewhere, there is a world without mini-bars and IDD and Visa and, most of all, CNN, we move onward, ever onward, like caribou, like lemmings.

But this gigantic migratory urge begs a serious set of questions – given that we think we know about the present state of humankind. Is this fidgety state of ours, so much more pronounced than it has ever been, a healthy thing ? Is it a force for good for mankind, something that improves the well-being of the world? Or is it, as Pascal remarked, at the root of all man's many ills, the source of his dissatisfied unhappiness? Is our present-day wanderlust a curse, or is it a boon? Can what makes our modern world so small bring upon it, in some unimaginable way, some real and lasting harm.

The images that follow, with their funny, sad and savage ironies, hardly show travel as a pleasure, either for those who do it, or for those who are visited by those who do it. The very word *travel* denotes a kind of suffering.

It has, after all, the same root as *travail*, and both words come from an ancient Romanism that meant some kind of three-legged engine of torture. To go on a travel, men hundreds of years ago would write, was to undertake a penance, a venture that had more to do with sackcloth than with suntan oil.

Yet a penance that has always been a central feature of man's development and – to use a word that straddles both the action and the consequence – of his *progress*. The progress of travel mimics the progress of humankind. Consider how travel has unfolded in human history – particularly how it began, tens of thousands of years ago, when primitive man first stood alone in what he imagined to be the limitless solitude of the world.

He had no idea where he was, nor why he was there. All he knew was his primal urge to keep alive – and to do that he knew that he must leave the safety of his shelter, and hunt and gather plants and animals, and bring them home as food. It must have been hugely difficult, a major act of courage, to step briefly out into the wild unknown, and to risk goodness knows what. It may have been a brave man, as they say, who ate the first oyster – but braver still was the first man who ventured into the terrifying mysteries of the great outside.

Real travel – travel for other than the most atavistic reason of survival – began only when man had settled himself, had taught himself about crop rotation and animal husbandry, and built himself a house and surrounded it with a wall. Only then could he look one day at the hills on the far horizon, wonder to himself what might lie beyond them and then, in a decision of unimaginable bravery, elect to walk to them and beyond – to travel purely and simply because he was curious. In an instant the notion of *man as explorer* was suddenly born – and with that profoundly important shift, so the world's horizons suddenly stopped being barriers, and the planet's dimensions truly began to shrink.

After that, other reasons sprang up thick and fast. He walked across his mountain range and found other men on the distant side. Maybe he traded with them – thereby inaugurating travel for trade, for commerce, for business. Or perhaps he was hostile to them, or they to him, and he returned to battle with and defeat them: travel for war, whether that war be the Crusades or the Falklands, makes a constant reappearance down the centuries. Perhaps he decided mere conquest in battle was not enough: he wanted his people to have control and command of the land of that people: he travelled for empire, to make a subject people bend to his will.

Or maybe his motives were more benign. He went to preach the word of his god to the outcasts who lived beyond the Pale, or he went to find some icon of his religion or his calling – the travel of the missionary, and the pilgrim, has a long tradition: the wandering *saddhu*, the palmer with his walking-staff, the devout on the camino del Santiago de Compestela...

Perhaps he went in the cause of science, or of plant-collecting, or simply to learn of foreign ways and

culture: the Grand Tour began in the eighteenth century, offering the youth of the time a means of adding the finishing touches to his education. And as a means, no doubt, of reaping some pleasure from the delights of warmer and more exotic places than the unexciting sameness that is Home.

For until the Grand Tour, very few people ever associated travel with pleasure. Now, though, young and enthusiastic Grand Tourers came back home, healthy and happy and burnished by the Mediterranean sun, and with tales of the real pleasures to be found in foreign wine and food and customs and people. To journey among such delights, they said, was a wonder. Others, the first true foreign tourists, began slowly to venture abroad as well.

That is not to say that tourism hadn't been around before – there is enough Roman graffiti in Pompeii to suggest that strangers were coming to gawp at the ruins two thousand years ago. But here, instead was deliberate, long-distance, cross-the-sea travel for pleasure, where people ventured towards the sun, towards *abroad*, to savour the qualities of foreign living that had hitherto been forbidden or unrecognised. It was the simple foreignness of the far-away that gave it its allure, that made the curious want to be amongst it.

After that it was just a matter of time before travel became truly democratized, once its practice had accelerated to the point where all could travel for fun. And in this lies the root of what we perceive as today's problem. For since all are now travelling, since all are going everywhere, and easily, and inexpensively – so everywhere is crowded, nowhere remains that is remote, all the world is becoming one, and the planet shrinks and shrivels before our very eyes.

We are fearful of the long-term consequences, not that we can imagine what they really are. We see MacDonalds in Bali or images of sacred buildings on Coke machines or hear the chatter of crook-speak in hitherto innocent corners of jungle Africa, and we think: something awful is eventually going to come of all this, the world is one day soon going to be brought low by it. Some try gamely to deal with the problem by the utterly eccentric idea of bringing the sights – or plastic simulacrums of the sights – home, and trying to persuade people not to travel, but to stay behind and see the fragile world *without going away*.

A whole new industry has been born from the manufacturing of such foreign-theme entertainment parks, the world brought to your doorstep by, first , the Americans (with both the outer world, and outer space, tucked into the more exotic corners of Disneyland) and then by the Japanese – who went on to develop the idea to a fine art, settling outside Tokyo an English village that is more brimming with thatch and swimming in bitter beer than anywhere in the Cotswolds. Soon the Europeans are to have such a *parc internationale*, with little great walls of China and petit Taj Mahals constructed in fields convenient for the fun-filled charabancs that converge on

Cherbourg. The evidence suggests, however, that these amusing attempts to render the foreign-going experience painless don't actually work too well. The human spirit still seems to demand some authenticity in the matter of *abroad*. All the high-tech simulacrums and the yards of vinyl thatch don't appear to be doing much to staunch humanity's restless outward flow.

Three centuries ago Pascal inveighed against the fact that travellers engaged in war and empire, covering all Europe and Asia with death and misery. Today we inveigh against the idea that modern travellers spread another contagion, that of cultural death, and that a blanket-spread of prole-culture, a low-brow veneer is being pasted across the planet by the "industry" of mass tourism. On the surface the criticisms and apprehensions, his and ours, appear very much the same.

Except that there is a point at which our views diverge. For though Pascal disapproved of the consequences of our species' restless nature, he also came to recognise and admit that there was a central importance to this selfsame restlessness. *Our nature lies in movement* , he was to write some time later. *Complete calm is death*. There was no fighting against it, he concluded: travel is a primal urge without which man simply cannot, and will not, exist.

And herein, *vive la différence*. For while Pascal was eventually sensible enough to limit his criticism, and to realise that however vile its side-effects travel was part of the vitality of man, we seem much less inclined to be tolerant. We see frightful souvenirs for sale in the Valley of the Kings, or we blanche at the ruination of Bethlehem or the Austrian Alps – and we blame it on mass travel. We prophecy dire and culturally fatal consequences. We wish, often vehemently, that every ugly tourist would stay at home in his living room by his wretched fire, and leave such noble places to their emptiness – or at least, to us.

Yet what we forget is that without travel – there would be no "us". For what is modern man, other than the consequence of movement, of migration, of wandering?

The first men who ever were lived beside the Indus, and in Persia, at Olduvai and on the flood-plain of the Nile, or in the Yellow River valley. It is thanks to the fact that they travelled – that they became nomads, that they became explorers – that they eventually moved and met and mixed and merged and found and fought each other, and then, slowly and steadily became peoples and nations and part of what we call today our global community.

Whole canons of civilisation followed. When, for instance, those first amazed Persians met those first astonished Egyptians – peoples who didn't resemble one another at all, and who had never before seen anyone looking like the other – when that momentous event occurred so there was created, suddenly, the first frontier, the first realisation that there were such things as nations, and nation-states.

And so the very underpinnings of our present human organisation came about simply *because man moved*, and

made the world a little smaller by doing so. Had he not – had he listened to some prehistoric version of Pascal, and chosen to lurk safely within his walls, in comfort and solitude – there never would have been a nation created upon the earth. Oh true – there would also be no nationalism, no wars, no genocides, no empire: this is what Pascal was regretting in his epigram. But a world without nations? A world denied the intercourse of states? A world without trade? A world without community? How barren a planet such a place would be! How sterile a place, had travel somehow been denied to early man, and had the idea of *home* been made more vital to him and his successors than the concept of *abroad*.

There is an organisation somewhere in America – California, I think, a location which sounds about right – that has as its motto *World Peace Through World Travel*. The aim of the body is a rather dotty one – it tries to have its members visit every single country in the world, and notch them up in a book provided. Since no-one in authority can rightly agree how many countries there are, this body makes up its own rules: it lists in the book the three hundred-odd entities that it chooses to call states – places like Midway Island, Scotland and Miquelon, in addition to the more prosaic and obvious choices, France, Brazil, Sri Lanka, Kenya.

Many years ago I met a man, a member of the organisation from Ohio, who on our first encounter was weeping hard on the taffrail of a ship in mid-Atlantic. The captain, it turned out, had said that the sea was too rough to allow this passenger off at Ascension Island – and yet had he allowed him the Ohioan would be only three places away from having "done" everywhere in the world. It would now, he sobbed, take him a year at least to come back here, and meanwhile a competitor from Germany was hot on his heels. His tears were very real. And when I asked him why he was engaging in so lunatic a chase, he pulled out his membership card. *World Peace Through World Travel*, he pointed out bitterly. That's why.

Though the man was clearly a little touched by his harmless madness, his stated belief – for I took him below, and we drank and talked away the rest of the storm-tossed night – was heartfelt. He thought that the more people moved around the world to see and get to know each other, the more they understood and tolerated each other, the more they learned of foreign language and custom and the more they took pleasure from such diversity as they found, so the more peaceful and content the world might be.

I have always remembered the meeting and, sentimental though his views may seem, I think he was more or less correct. I came to think so when I asked myself one simple question: what do tyrannies exact on their peoples, other than subjection at home? The answer: they forbid them from going abroad, they stop them going off to find and talk to others who are less constrained than they.

The Chinese didn't allow anyone to travel for five hundred years: even owning a boat was a crime, punish-

able by death by strangling, or the slicing-knife. The Third Reich halted its people venturing beyond its glorious borderlines. Japan didn't permit its citizens to pollute themselves with foreign ideas until 1964. South Korea allowed its people passports only ten years ago. North Korea still doesn't let its people go.

To be sure, the frantic ant-like movement of the world's more prosperous people today does produce unwanted side-effects. Tourism is a frankly vulgar affair, which none of us much likes, nor whose practitioners we admire. And yet, surely – how much better a world where travel, which for all time has been the lifeblood of civilisation itself, is permitted to continue, unchecked and unabated.

I suspect in any case that the checks and balances for which our species is so known will sort out the trifling unpleasantnesses before too long. People will eventually discover if Marrakech and Mazatlan and Monte Carlo are acquiring a dreary sameness about them, will conclude that they may as well stay near home next time, and will journey closer to themselves. There will be some solution. The forces of the market-place will do for travel just as they do for the rest of the unregulated world.

So I have no fears that the world will ever become, despite the relentless pressure from the jumbo-jets and the tour buses and the excursioners, too truly small to be bearable. And yet, perhaps far better to risk that it does, than that all travel is brought to an end, or that it becomes merely a pastime for elites. Far better than that we revert as a result to being a large world once again – but one in which citizenry have retreated behind their walls to glare at each other, to exist ignorant and mutually suspicious of one another, and like during the Cold War that has just ended, to live lives once more clouded by a permanent sense of fear.

If the price we pay for some kind of imperfect peace and harmony is a degree of sameness and gaudy excess – then so be it. Complete calm, as Pascal said, is death. Far better a vulgar shirt, a set of Golden Arches in Paradise and a huckster's grasping hand, than a grey-steel world where all is still, and lifeless, and cold and nobody moves any more, except as shadows behind the bars.

SHEPPERTON ARTS CENTRE
SHEPPERTON ROAD
LONDON N1 3DH
Tel: 0171-226 6001

MARTIN PARR

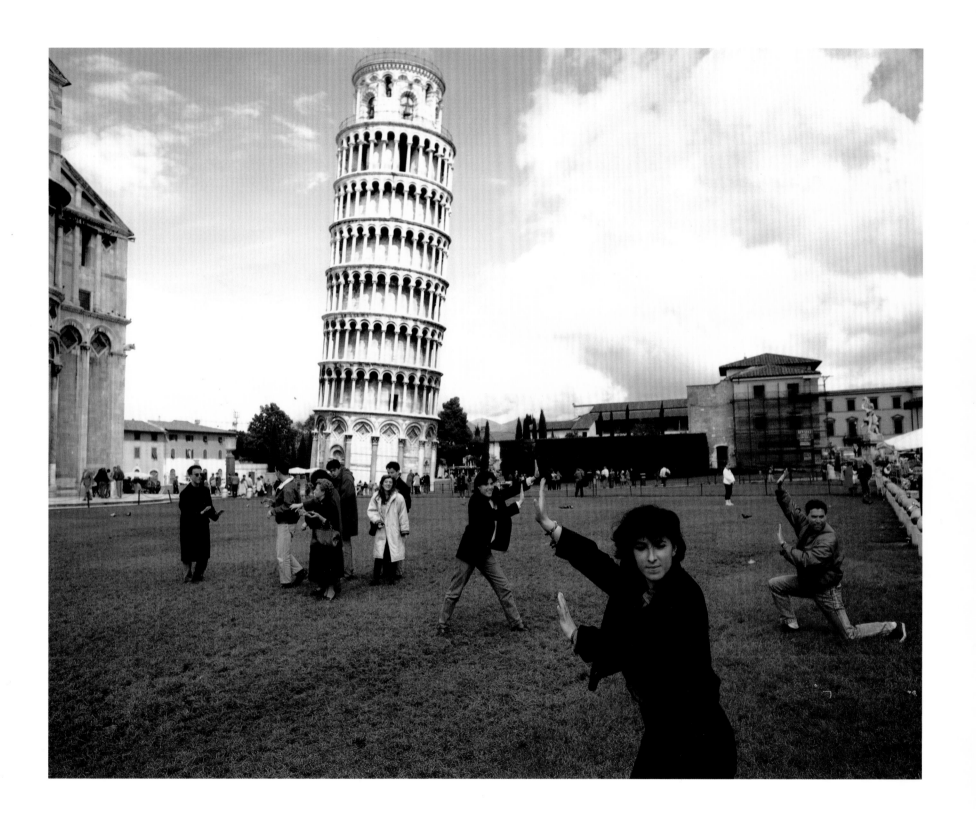

LEANING TOWER, PISA, ITALY

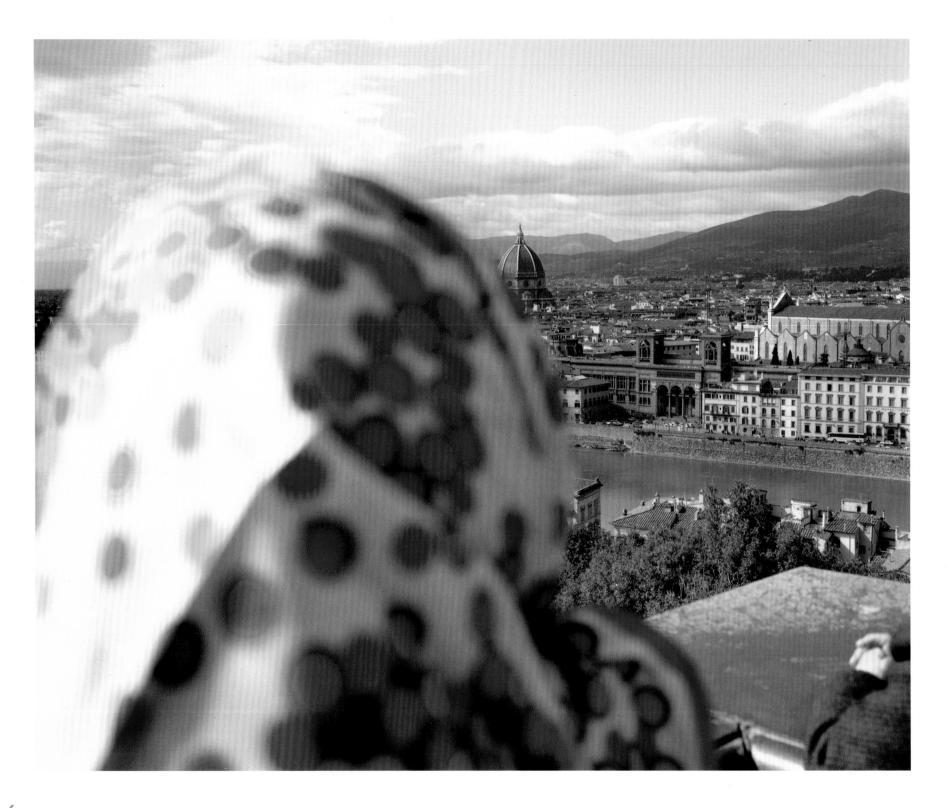

FLORENCE, ITALY

2

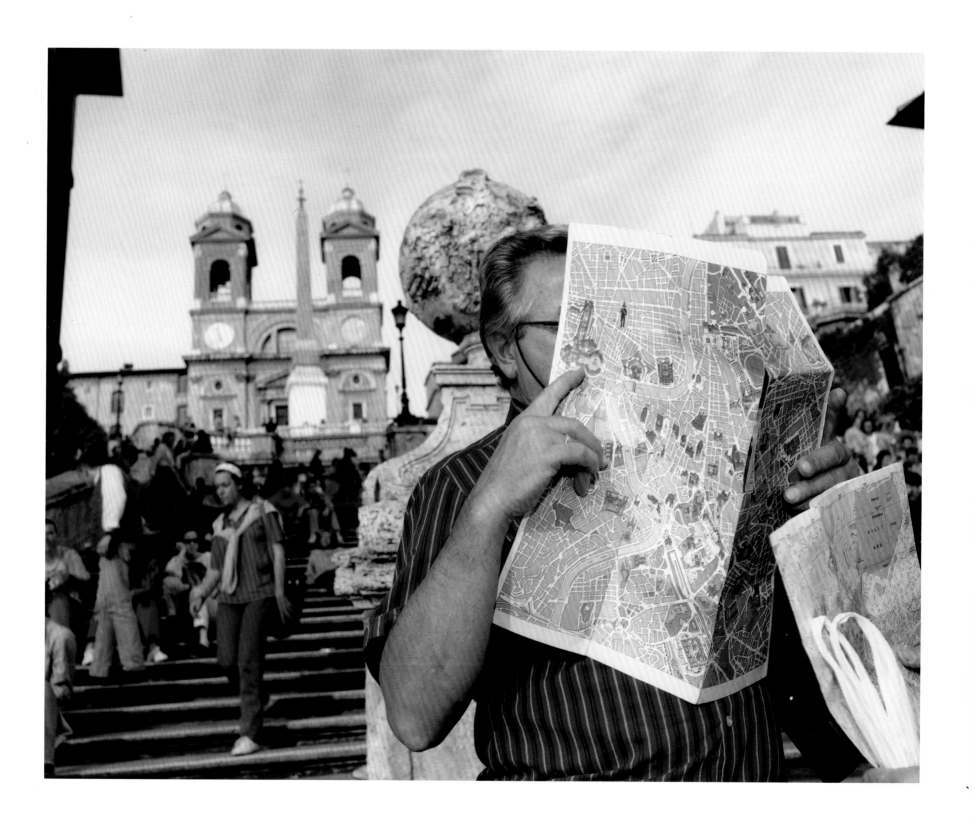

SPANISH STEPS, ROME, ITALY

3

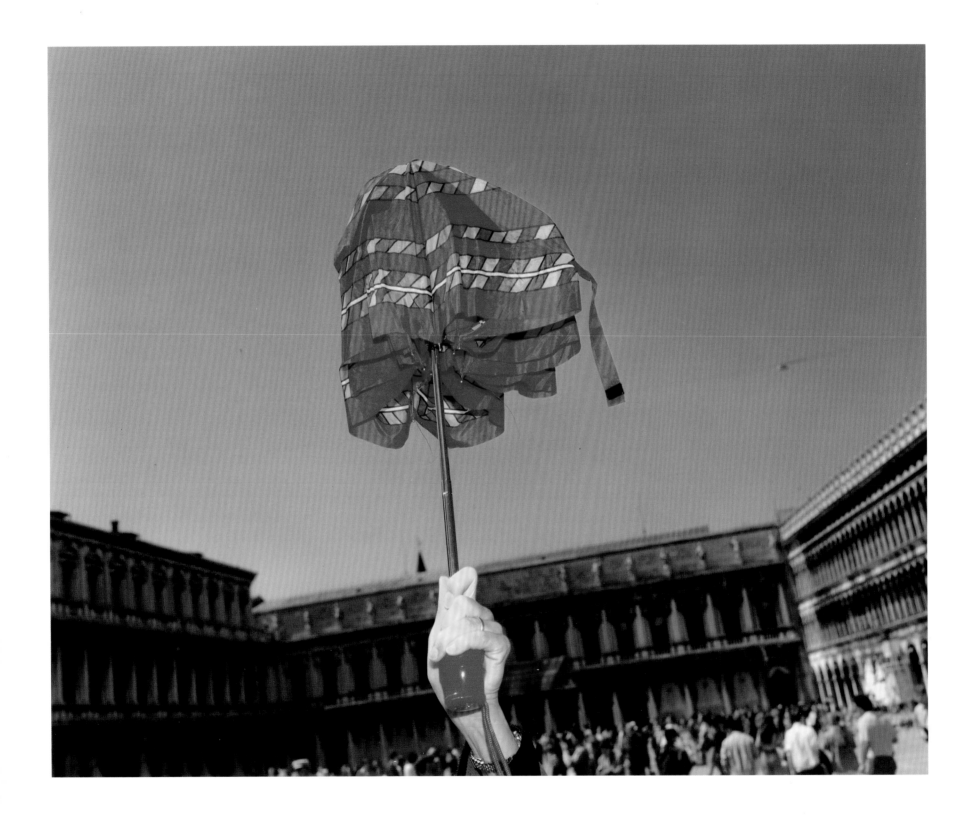

PIAZZA ST. MARCO, VENICE, ITALY

4

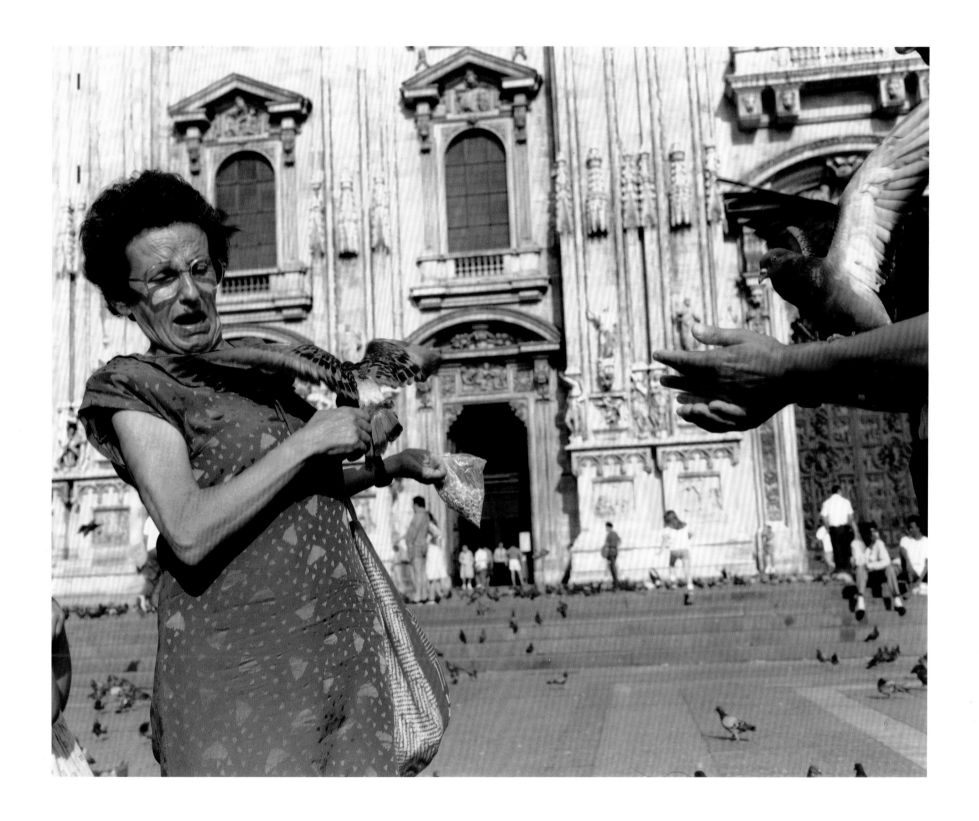

DUOMO, MILAN, ITALY

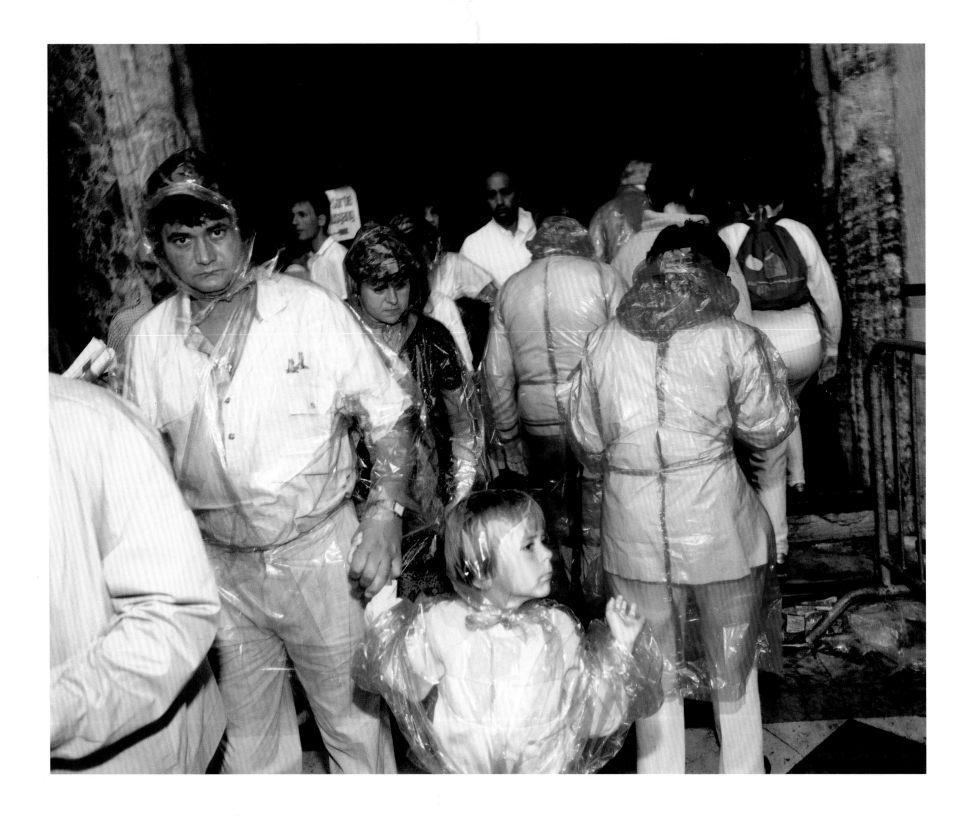

BASILICA SAN MARCO, VENICE, ITALY

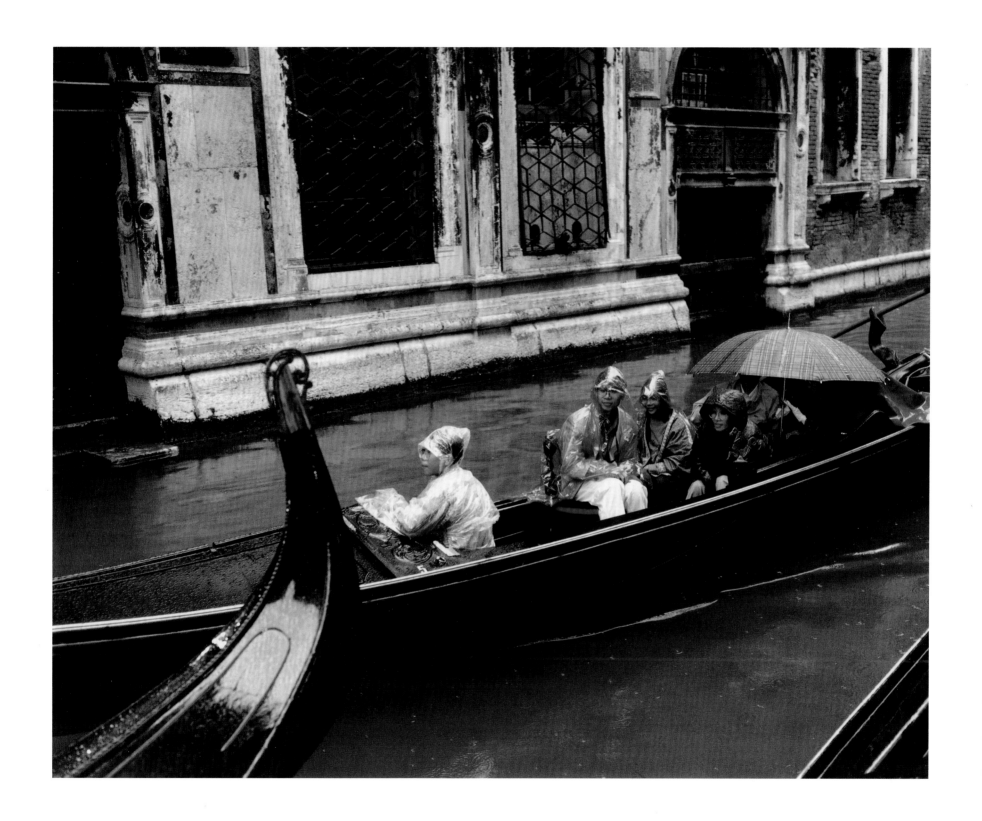

VENICE, ITALY

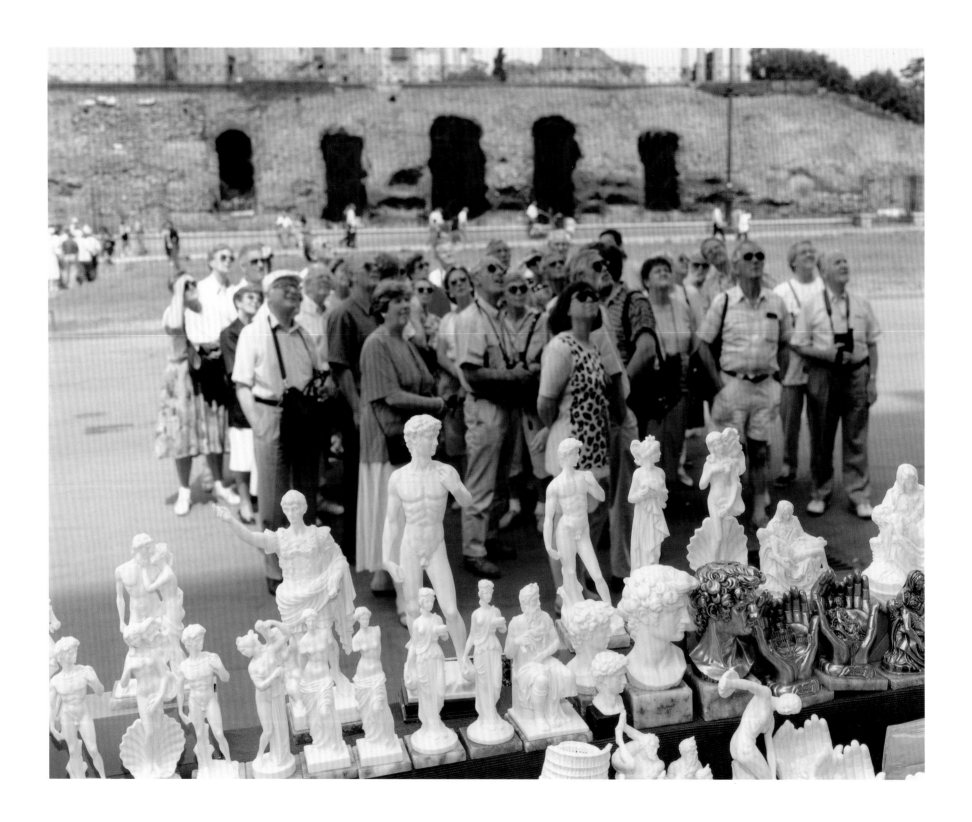

COLOSSEUM, ROME, ITALY

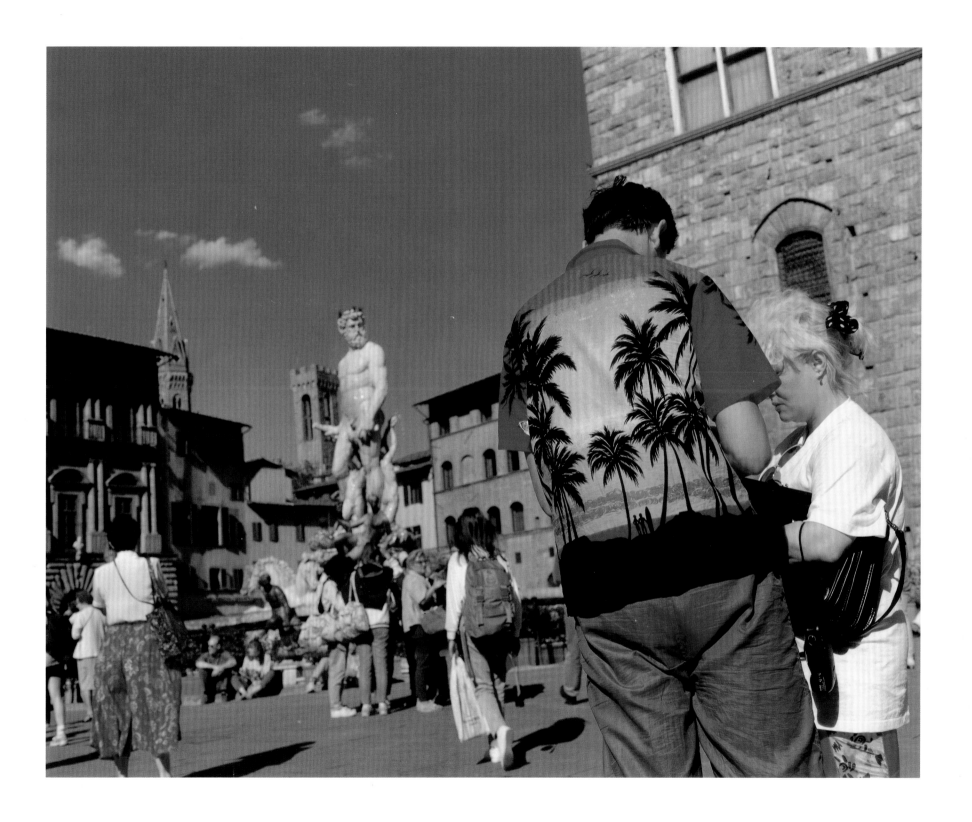

PIAZZA SIGNORIA, FLORENCE, ITALY

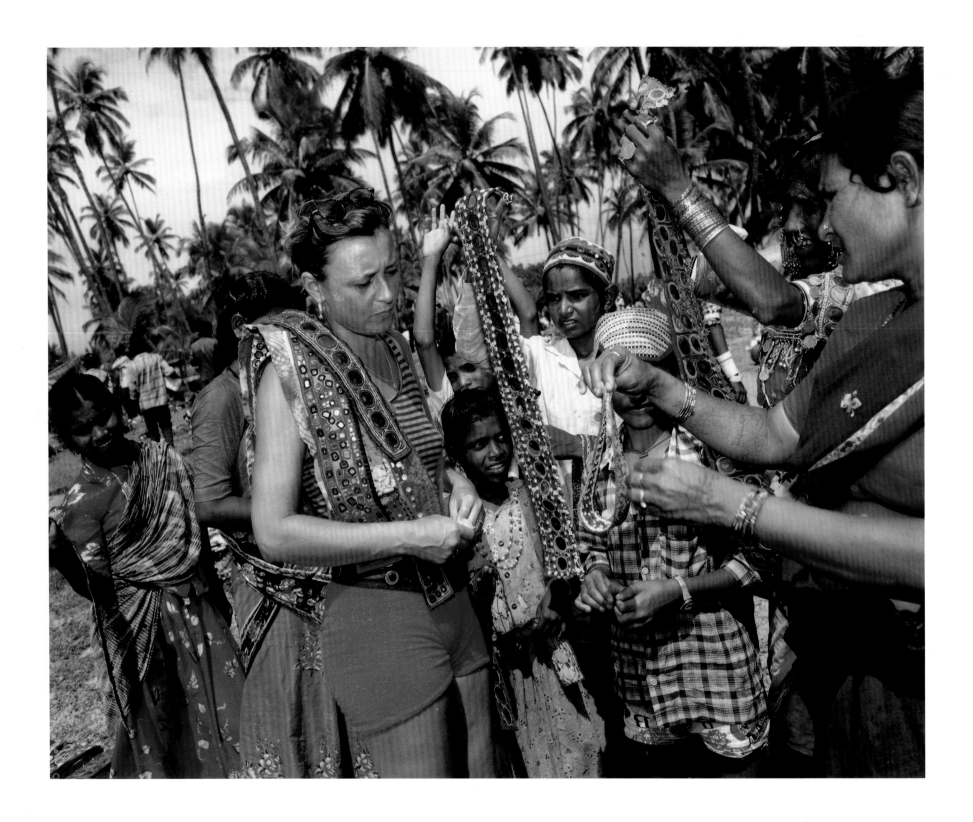

GOA, INDIA

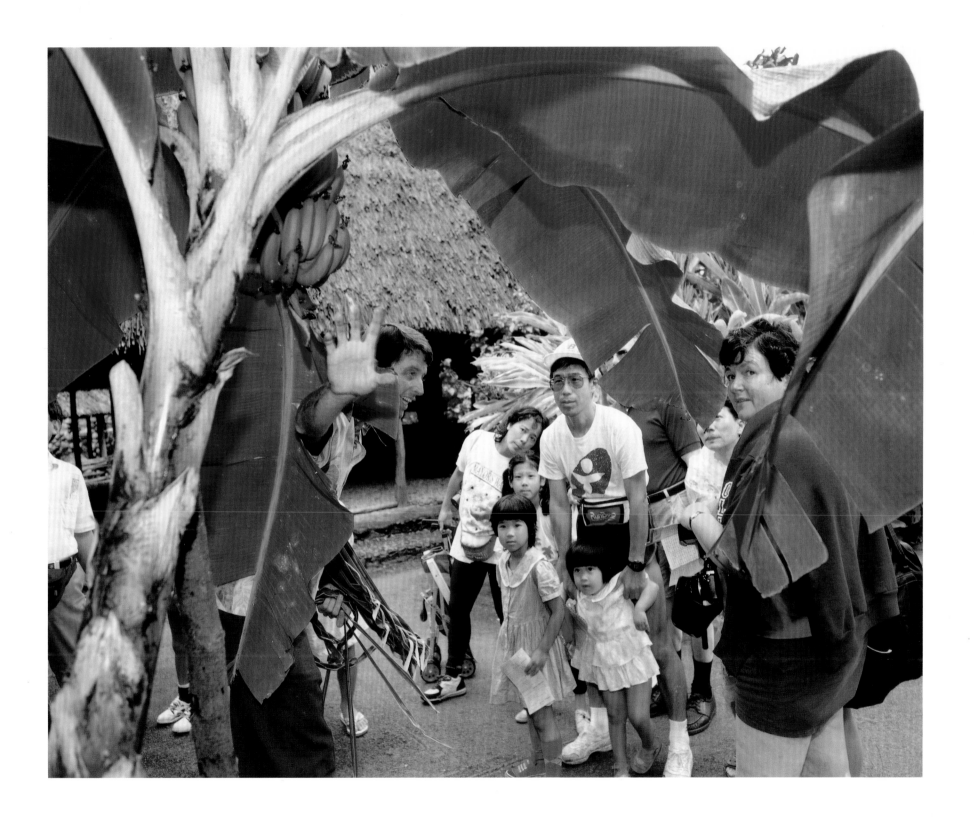

POLYNESIAN CULTURAL CENTRE, OAHU, HAWAII

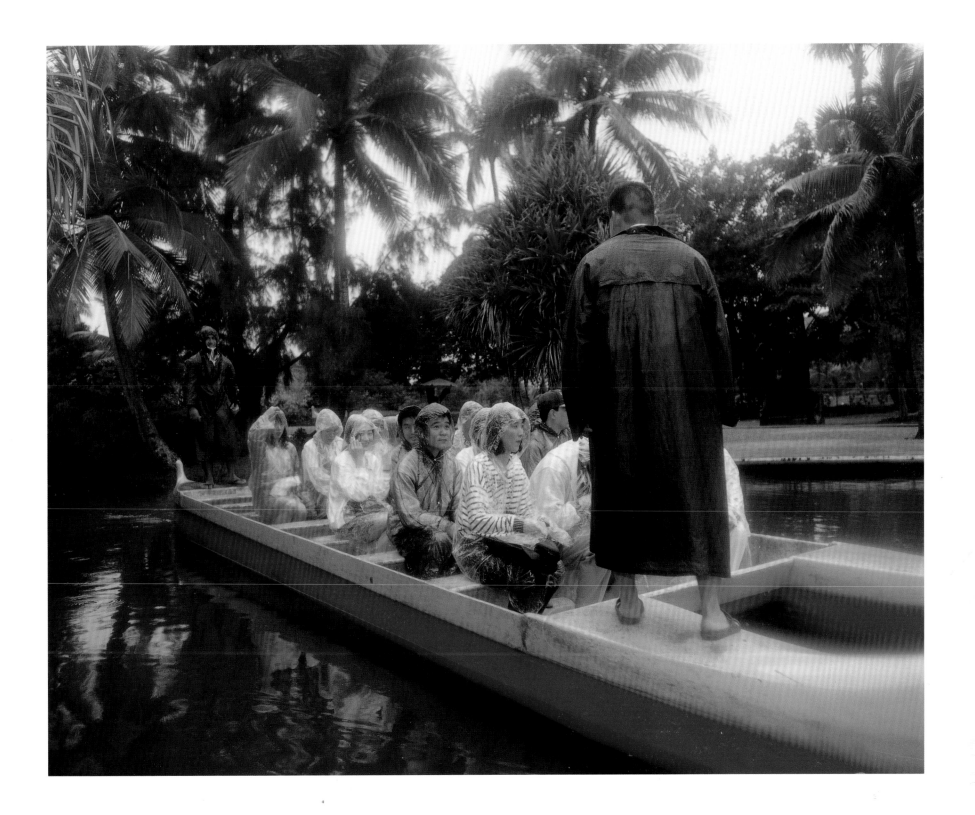

POLYNESIAN CULTURAL CENTRE, OAHU, HAWAII

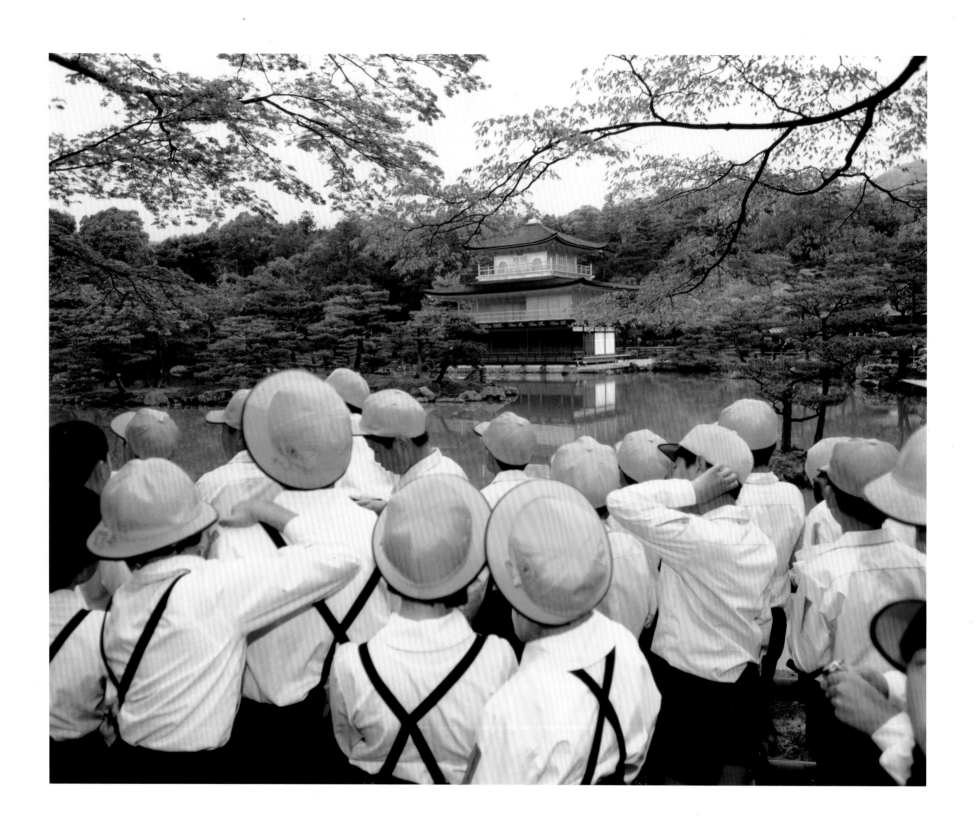

GOLDEN TEMPLE, KYOTO, JAPAN

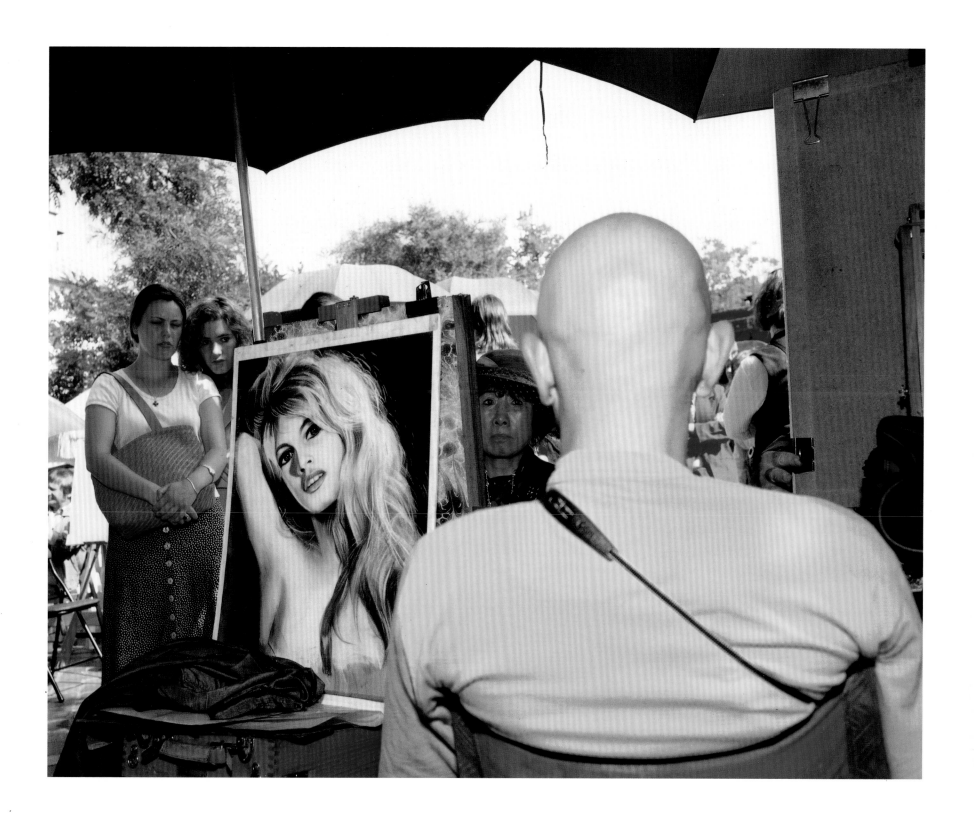

PARIS, FRANCE

14

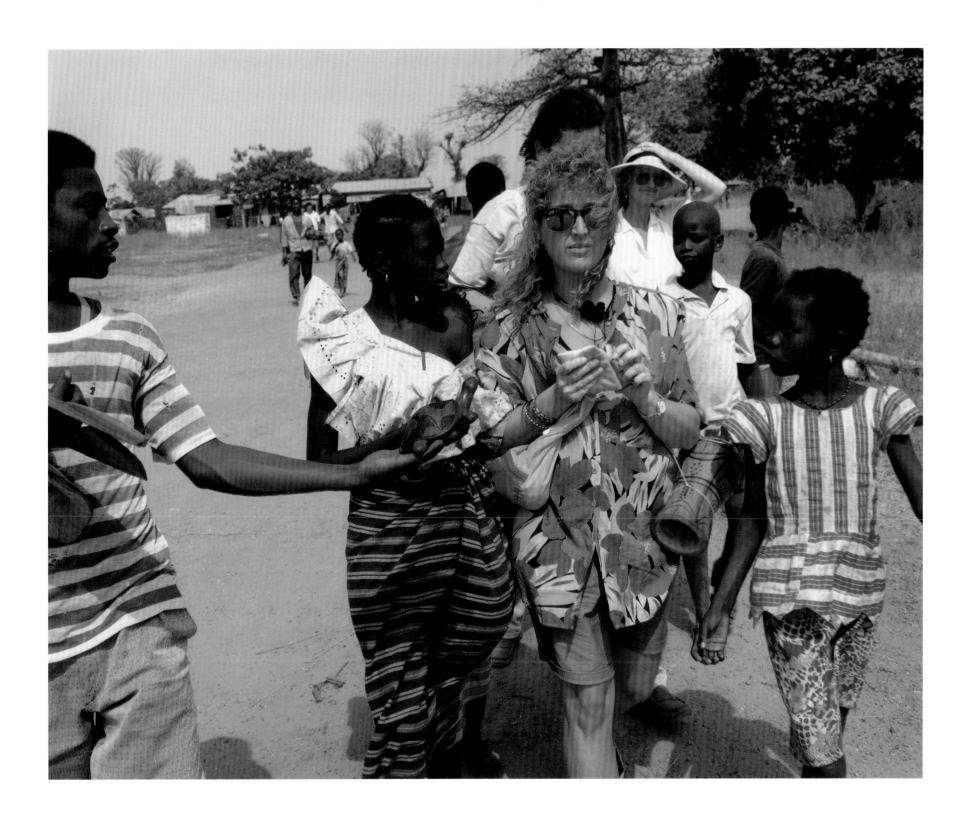

JUFFURE, THE GAMBIA, AFRICA

15

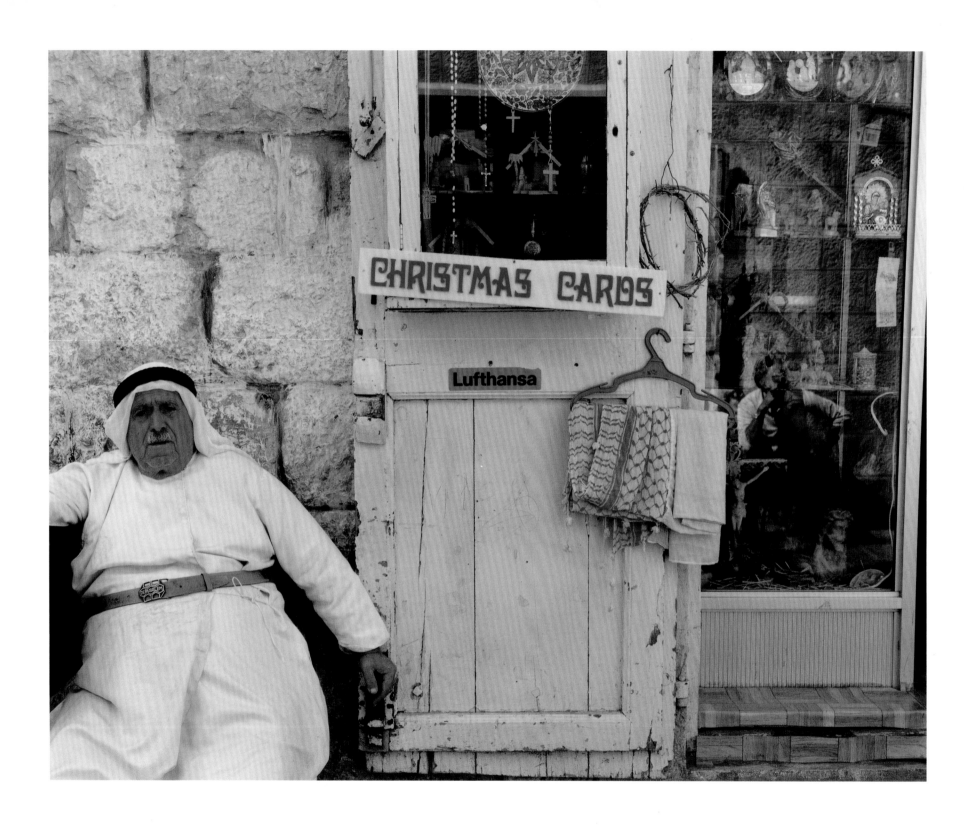

BETHLEHEM, ISRAEL

16

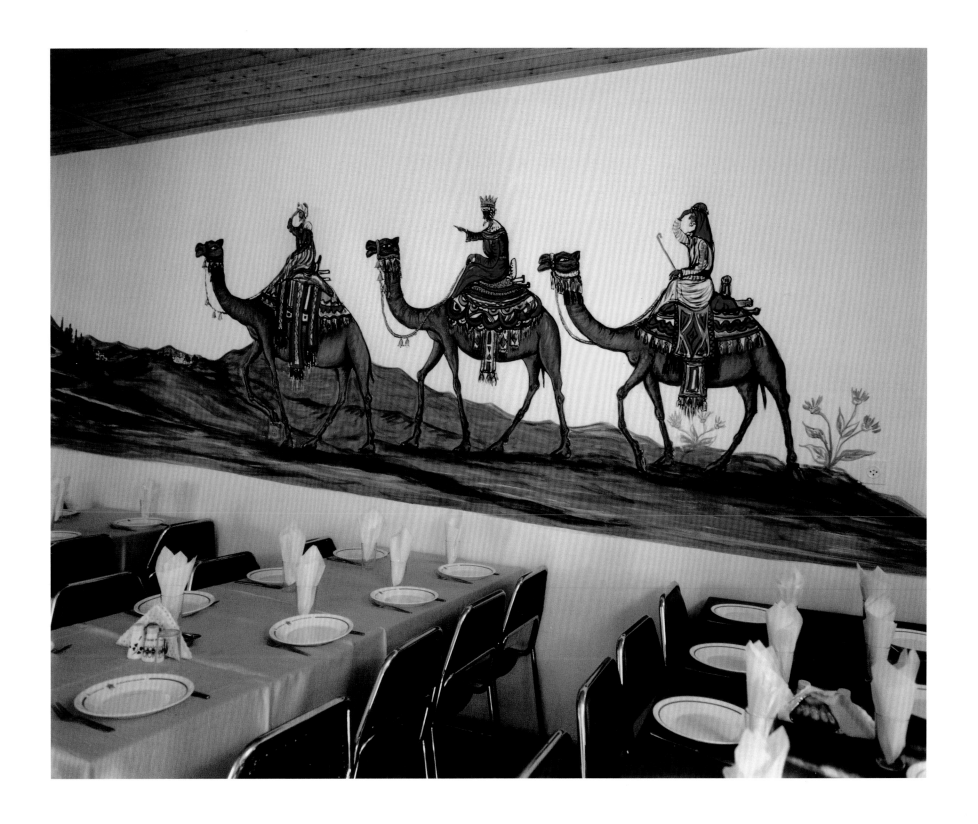

BETHLEHEM, ISRAEL

17

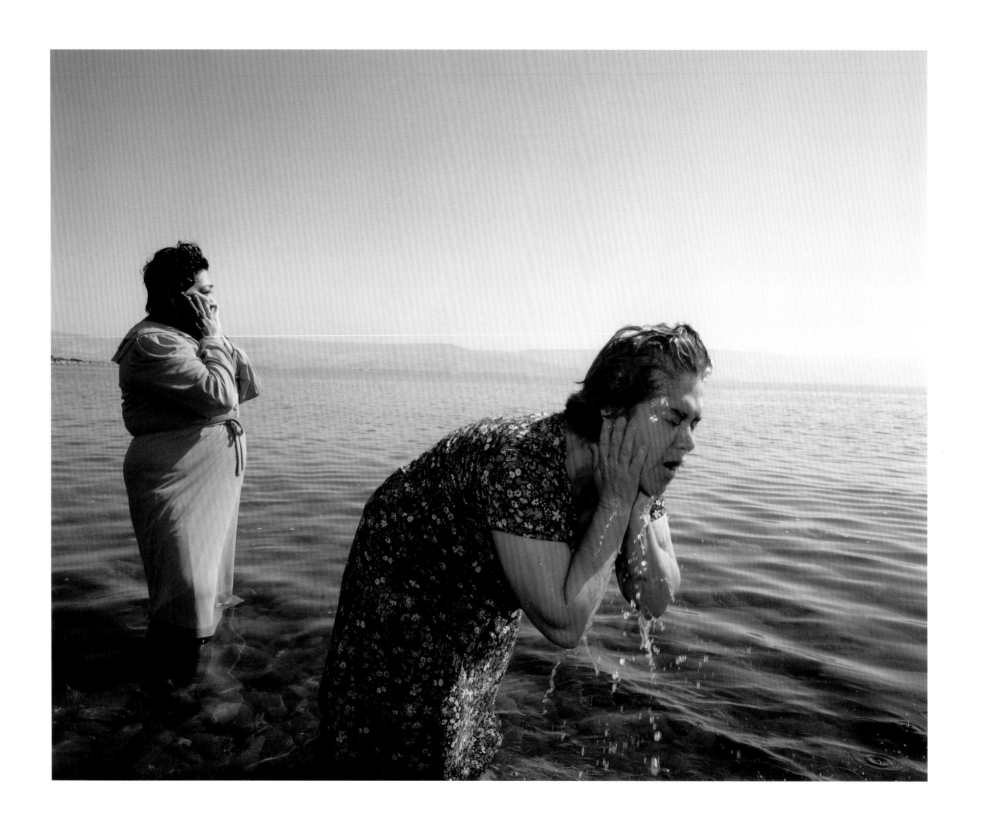

SEA OF GALILEE, ISRAEL

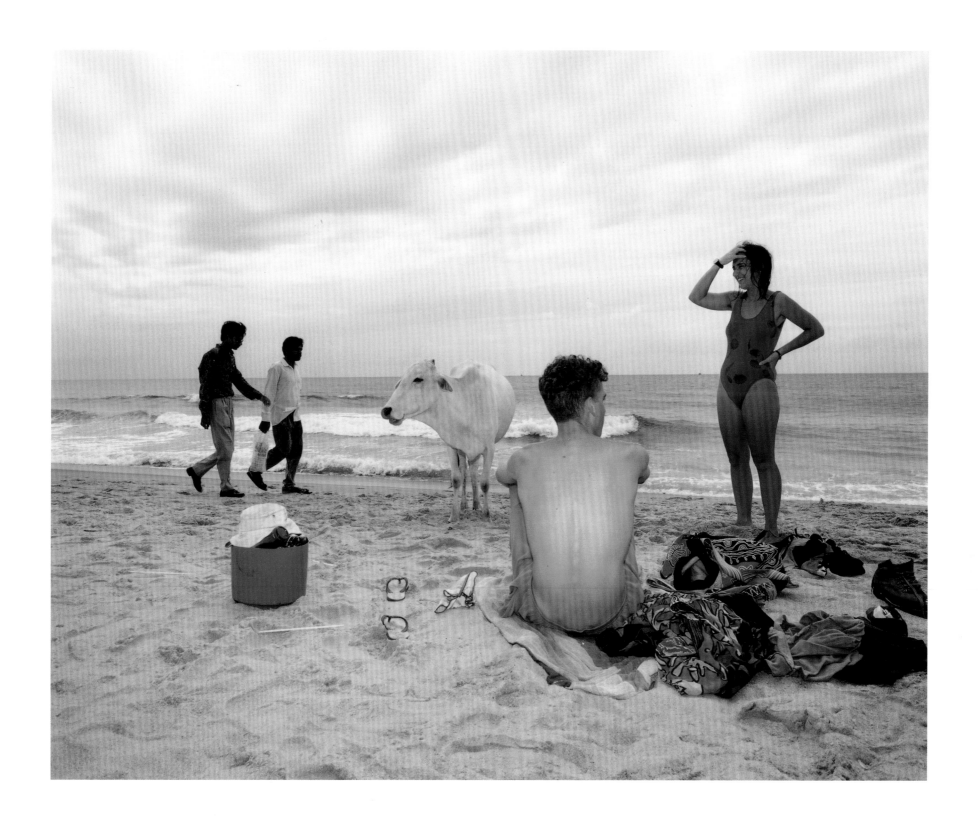

GOA, INDIA

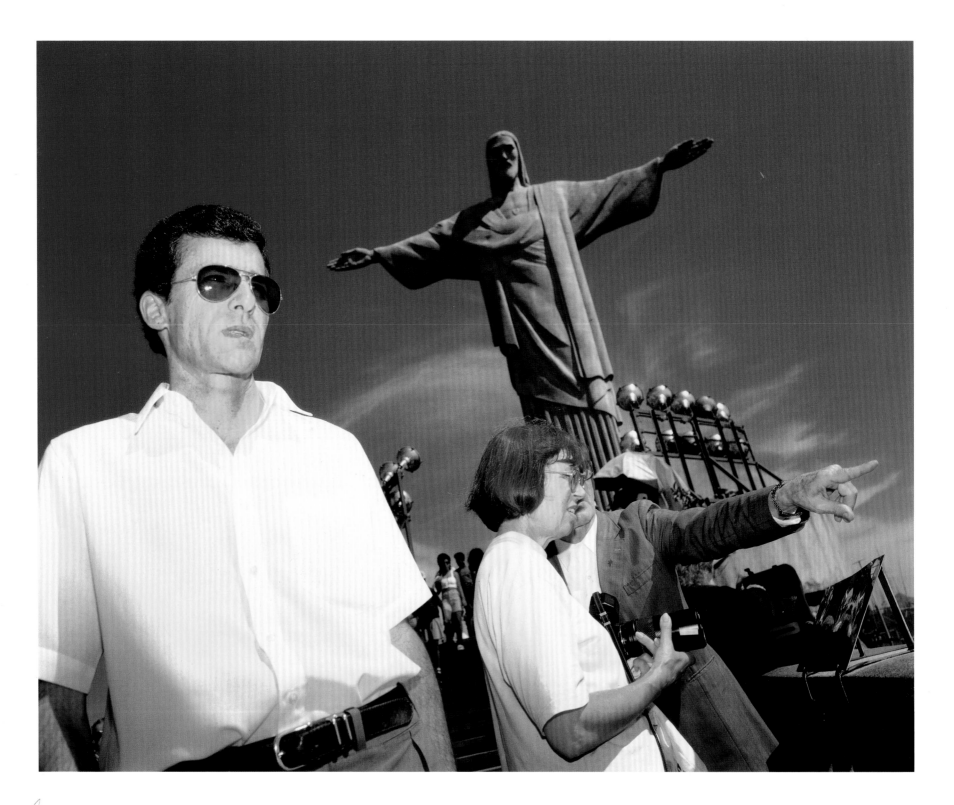

CORCOVADO, RIO DE JANEIRO, BRAZIL

20

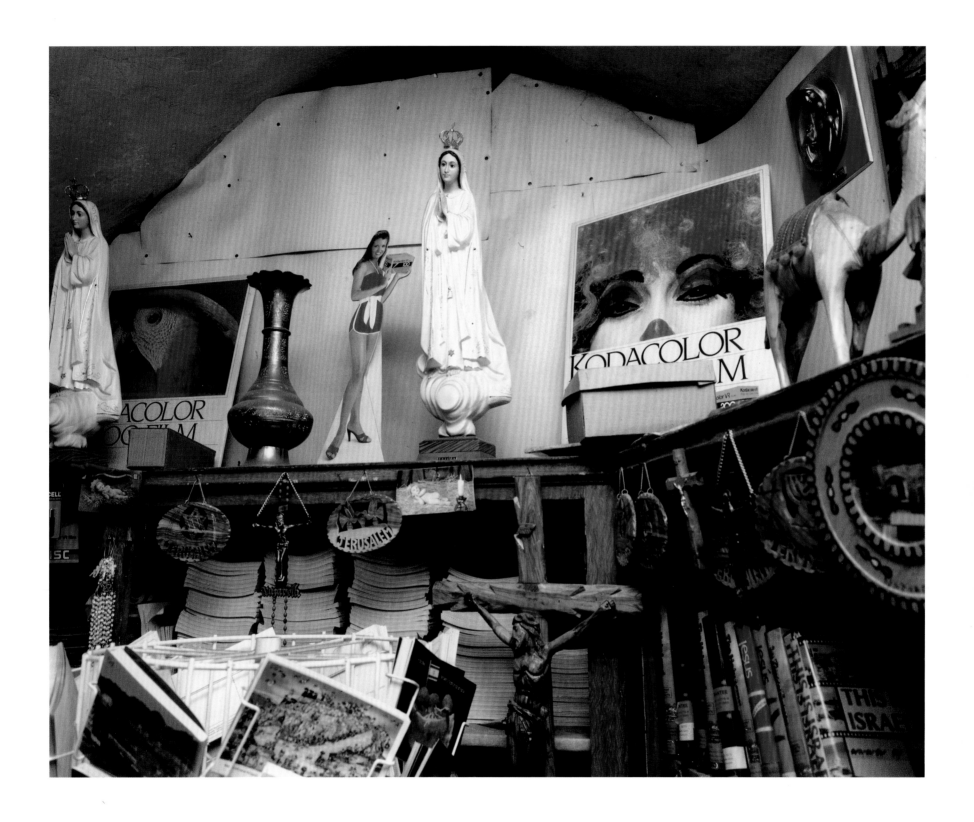

NAZARETH, ISRAEL

21

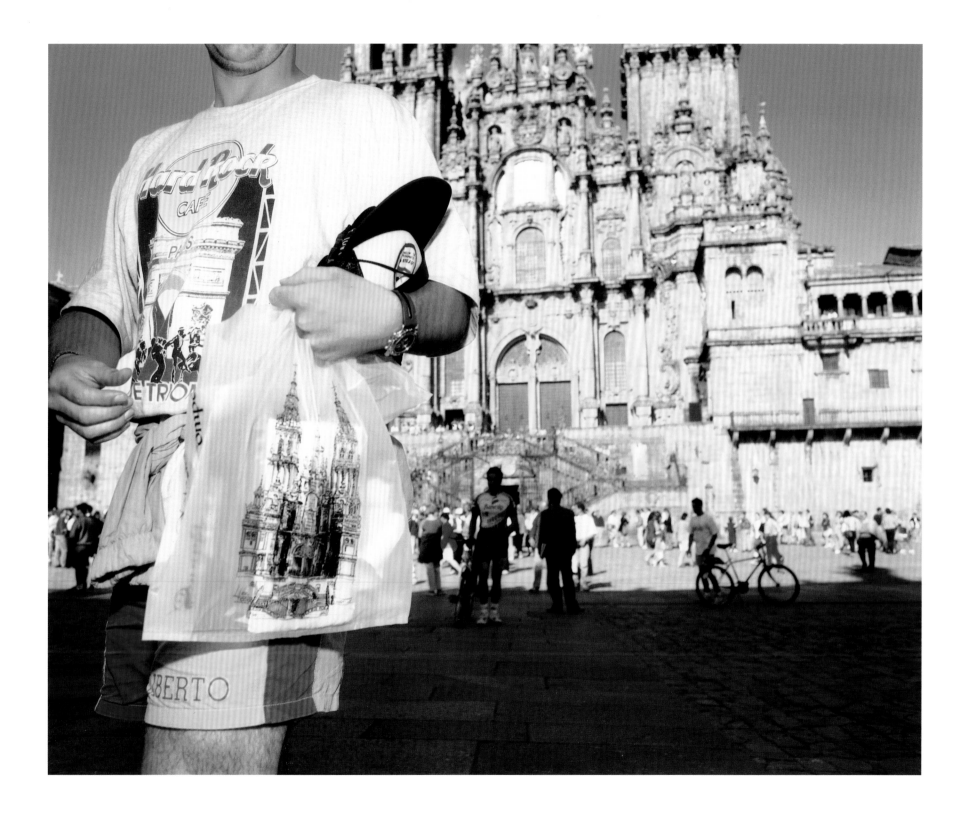

SANTIAGO DE COMPOSTELA, SPAIN

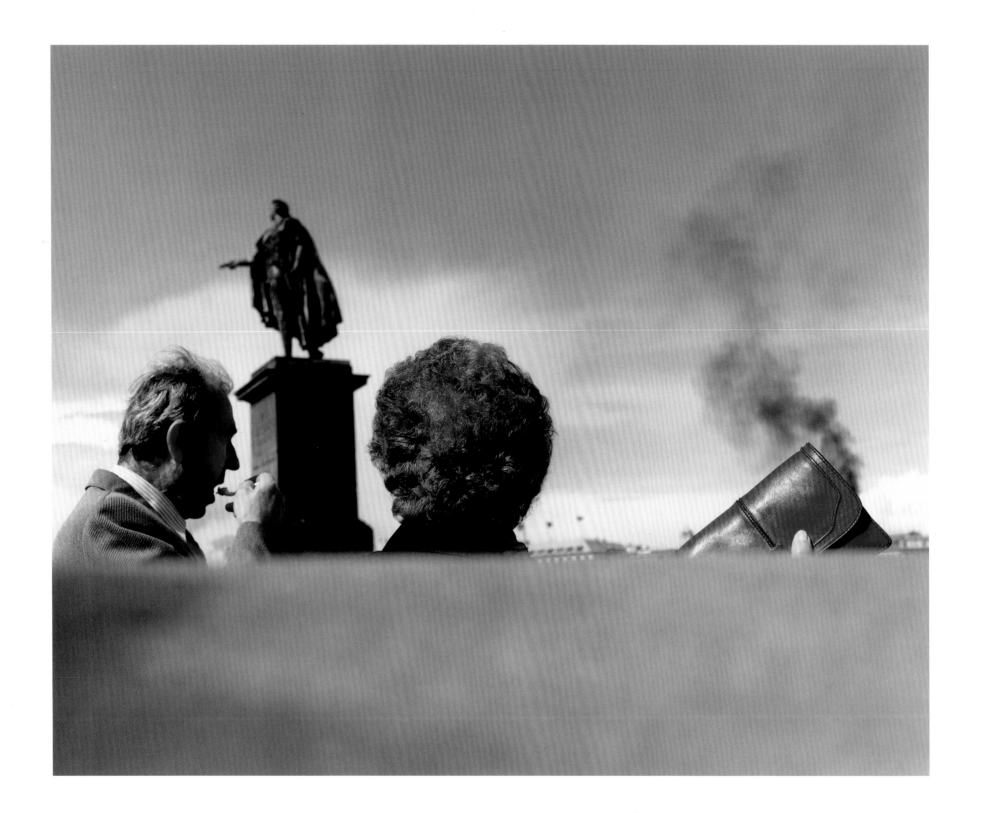

STOCKHOLM, SWEDEN

23

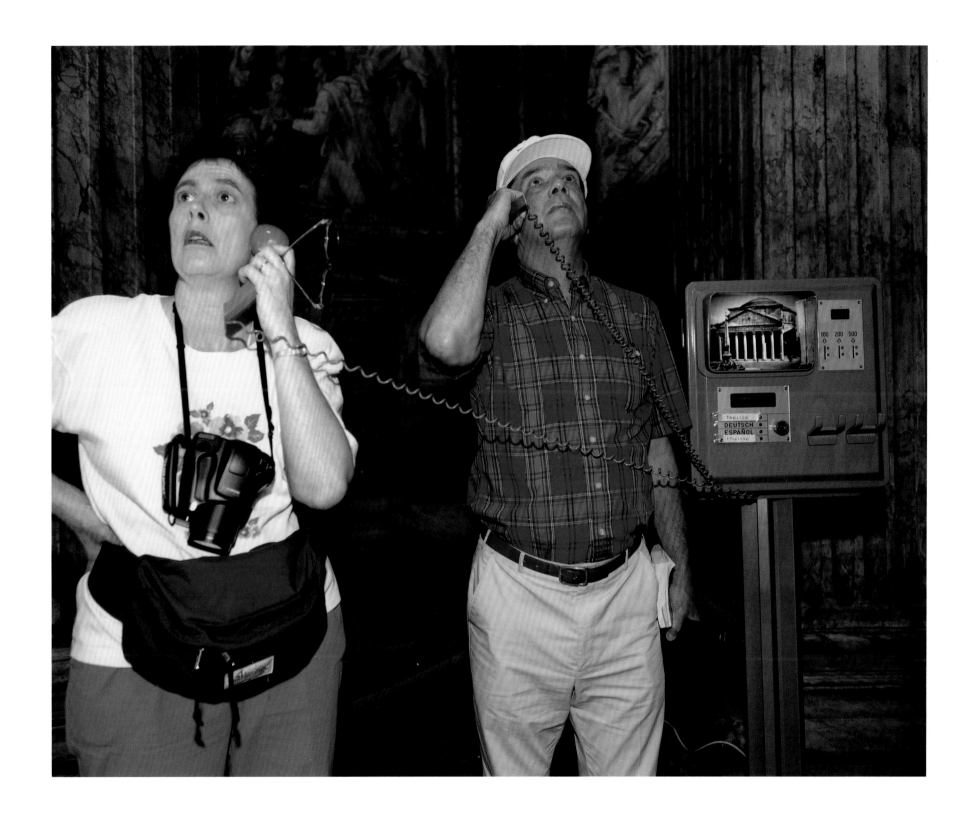

PANTHEON, ROME, ITALY

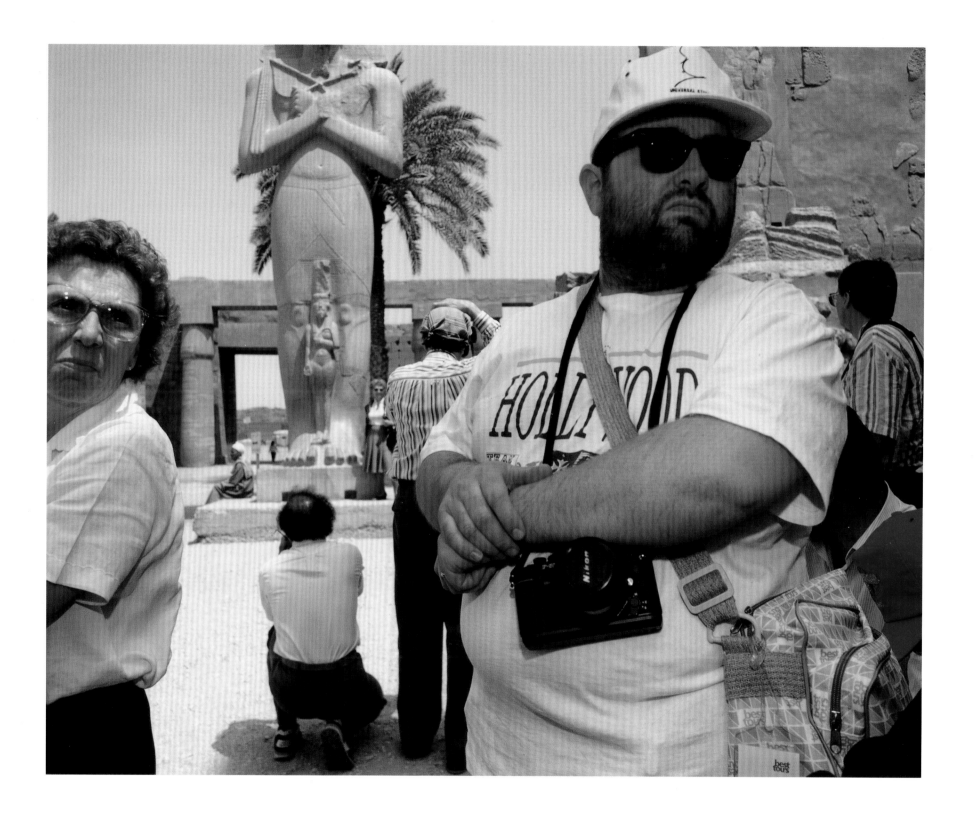

KARNAK TEMPLE, LUXOR, EGYPT

25

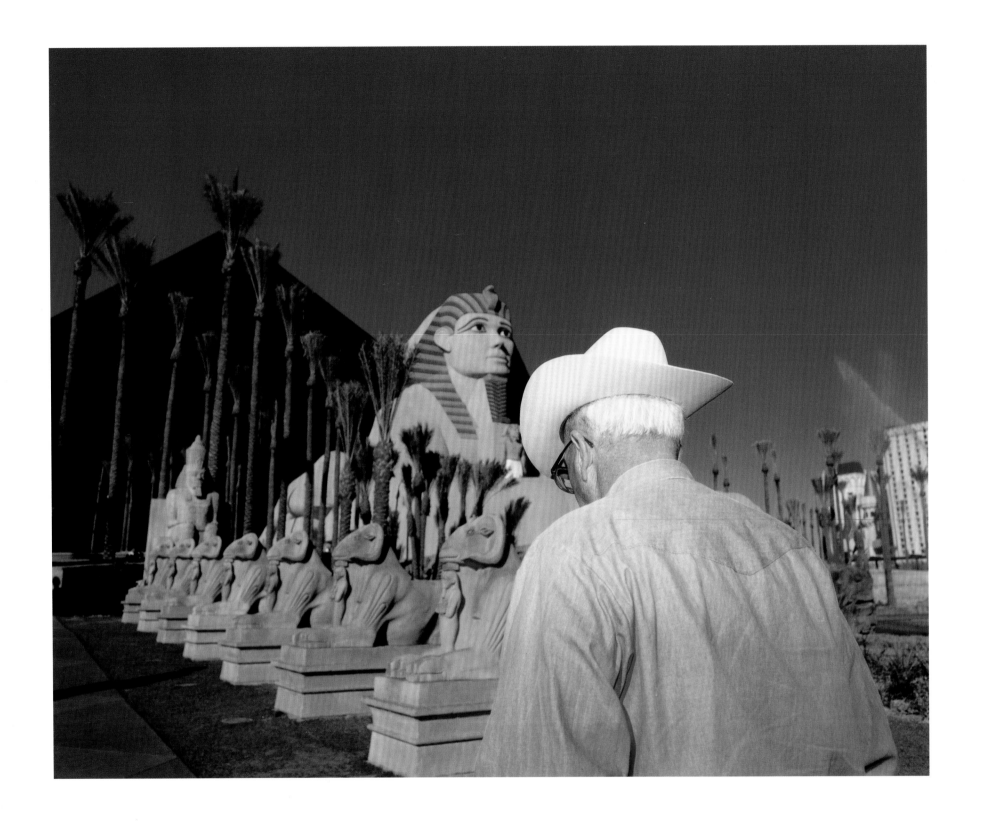

LUXOR HOTEL AND CASINO, LAS VEGAS, USA

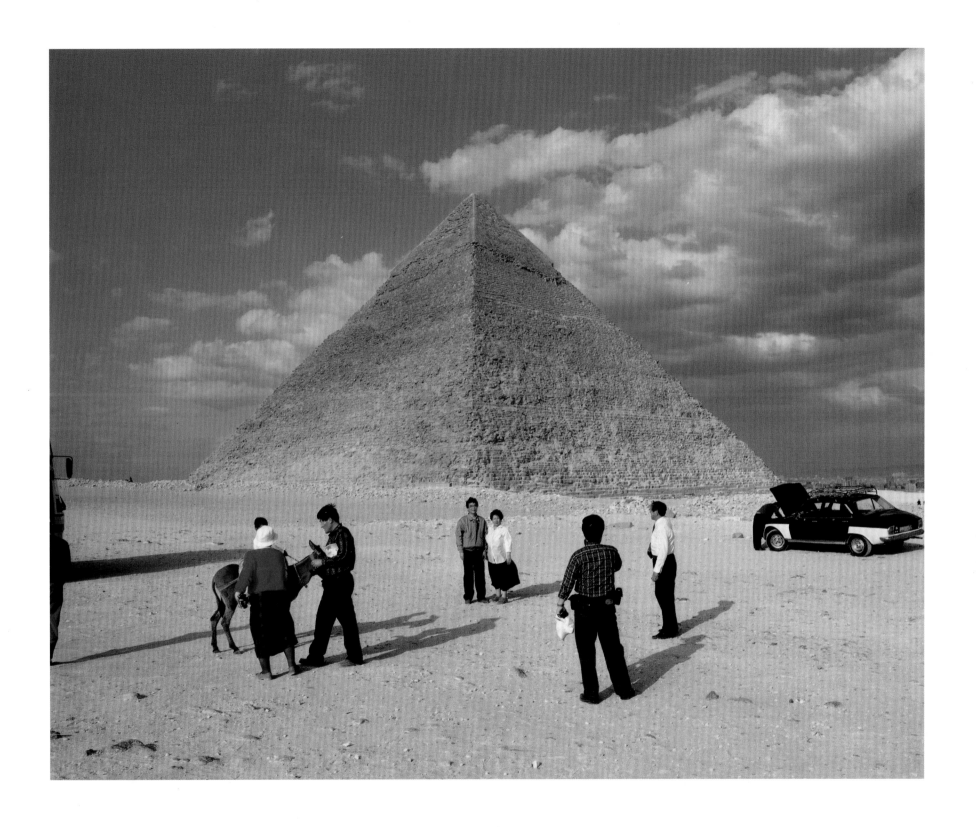

THE PYRAMIDS, GIZA, EGYPT

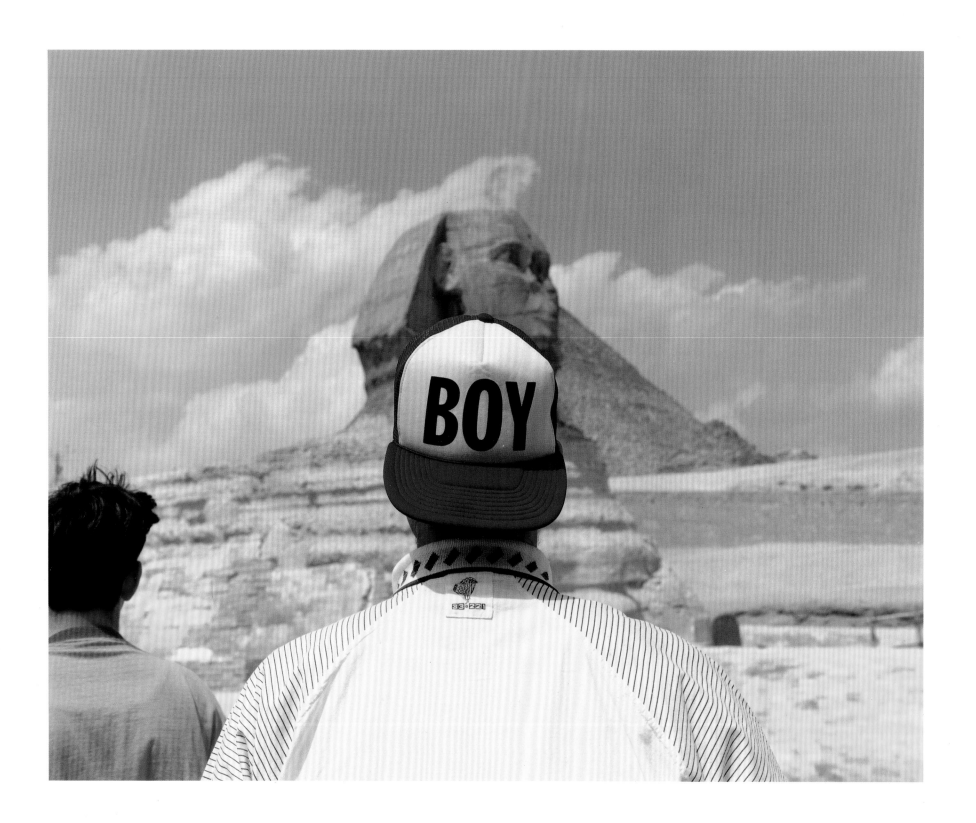

THE SPHINX, GIZA, EGYPT

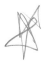

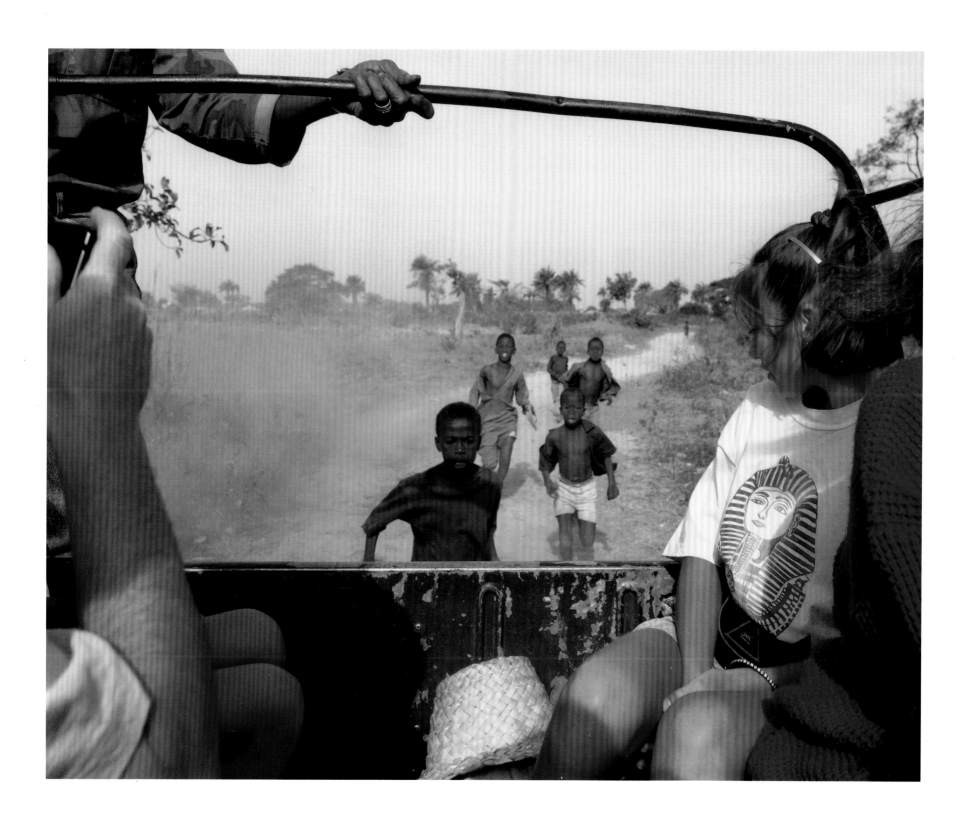

THE GAMBIA, AFRICA

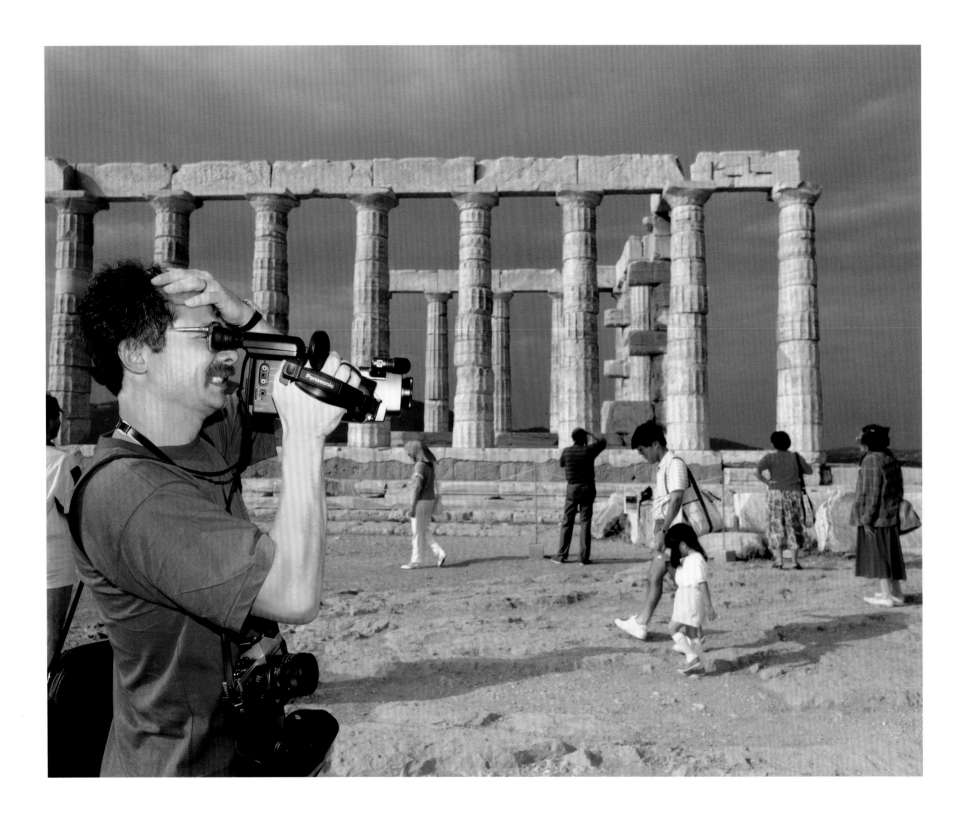

SOUNION, GREECE

30

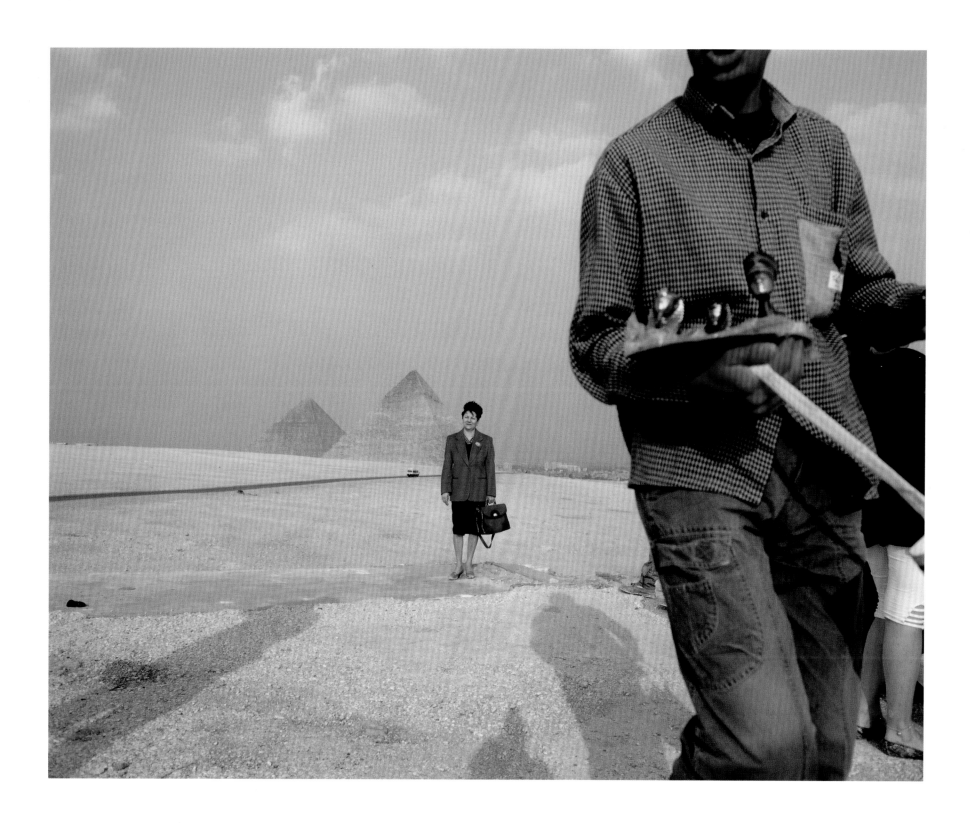

THE PYRAMIDS, GIZA, EGYPT

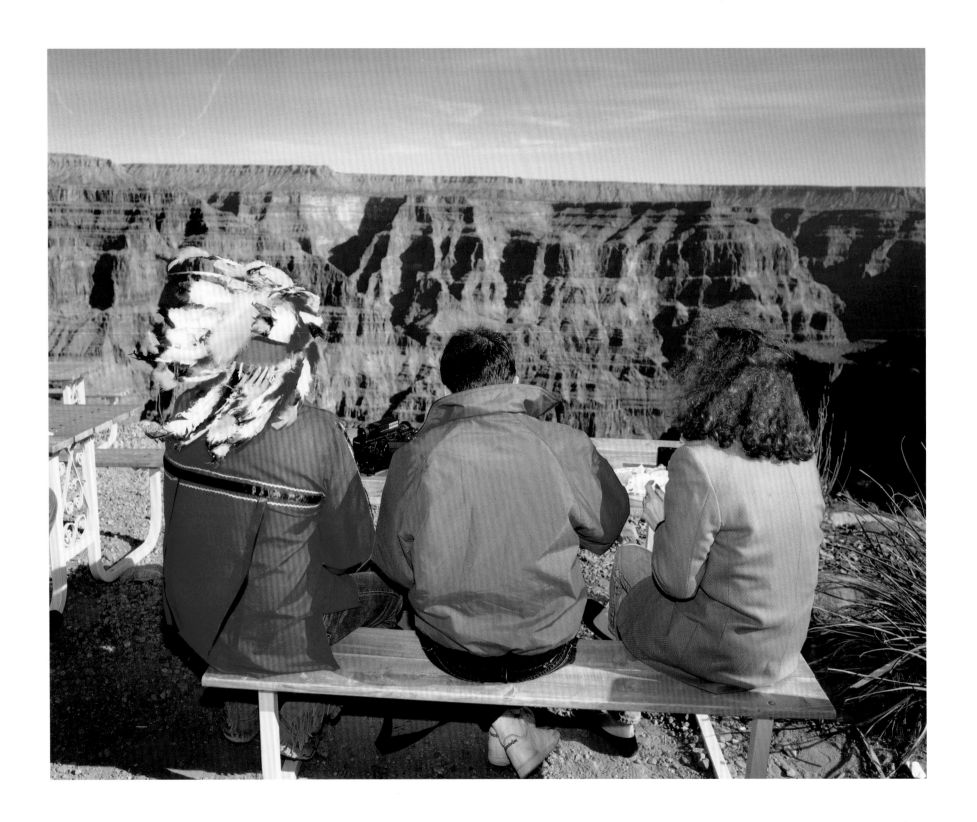

GRAND CANYON, USA

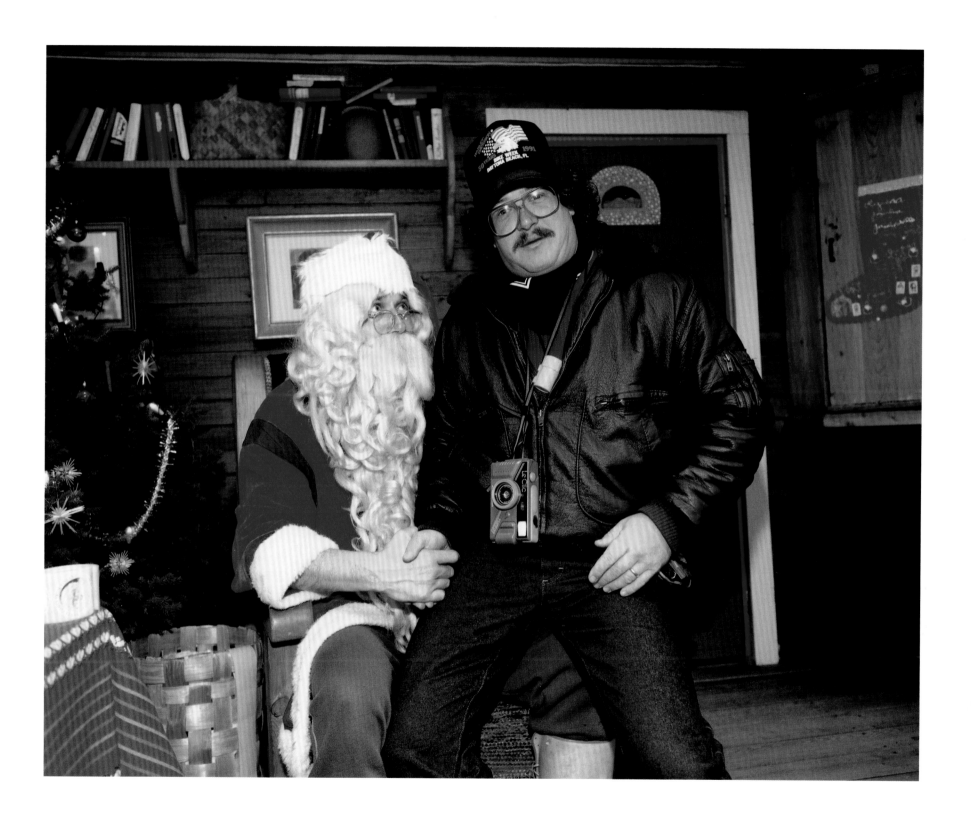

THE REAL SANTA CLAUS, ARCTIC CIRCLE SHOPPING CENTRE, LAPLAND

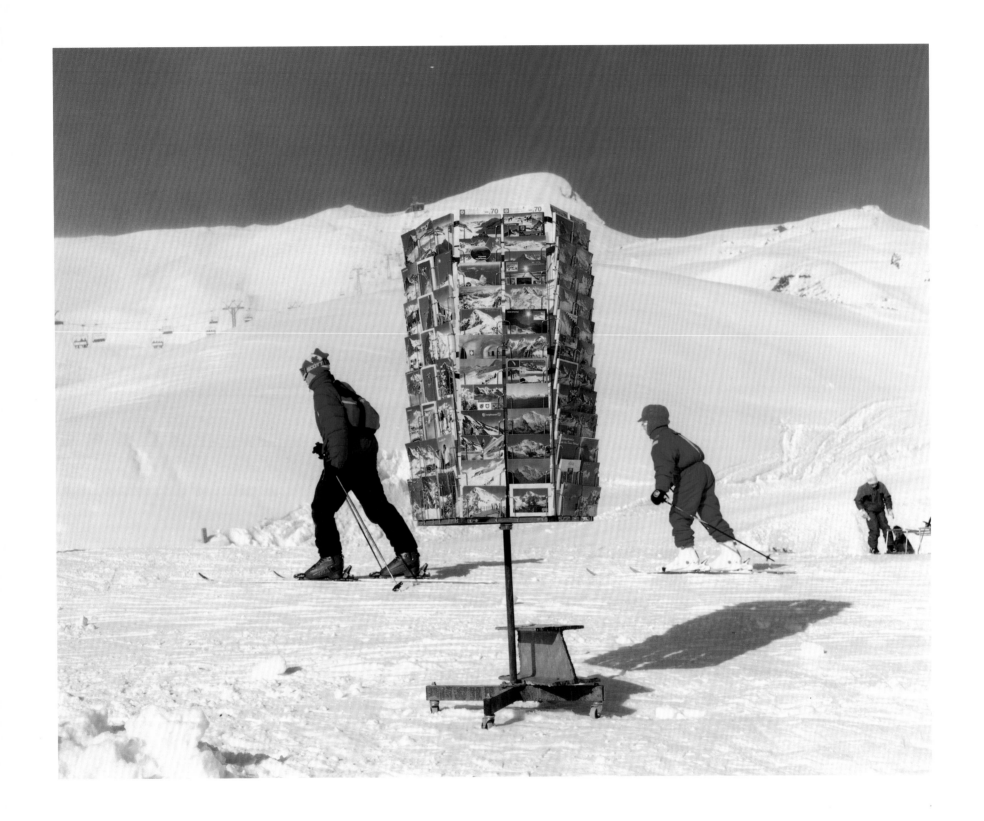

KLEINE SCHEIDEGG, SWITZERLAND

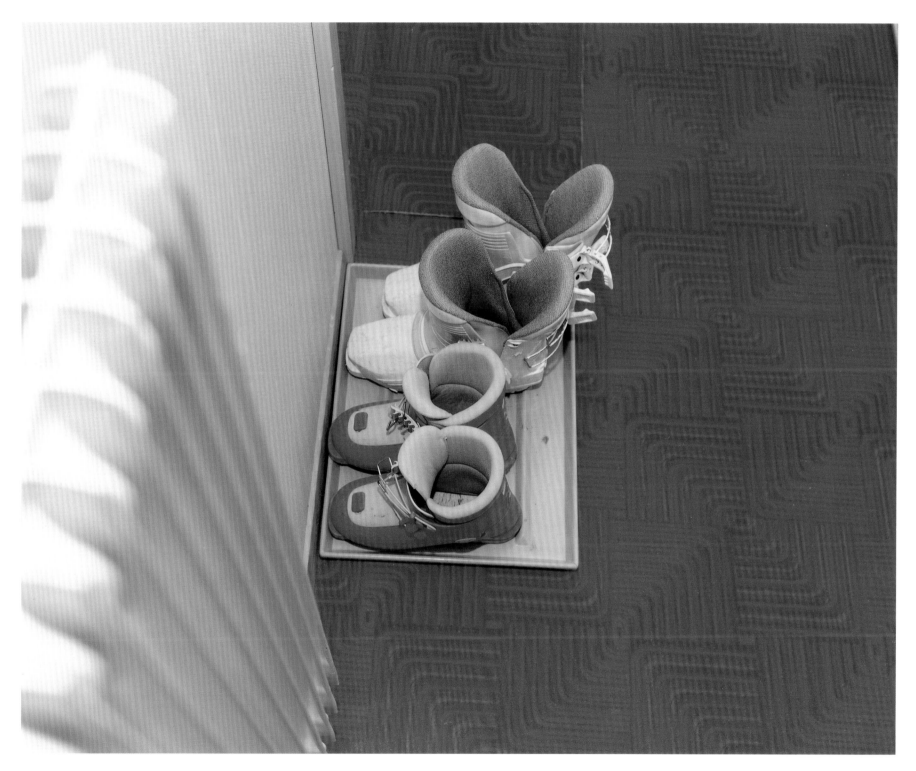

WENGEN, SWITZERLAND

35

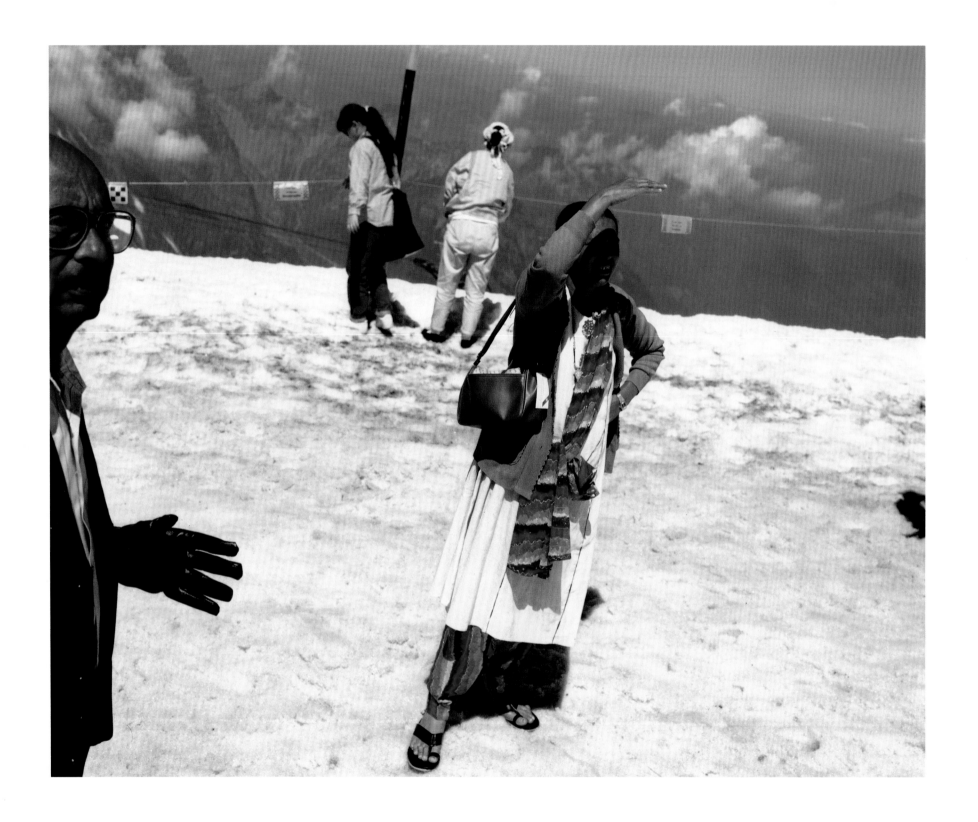

TITLIS, SWITZERLAND

36

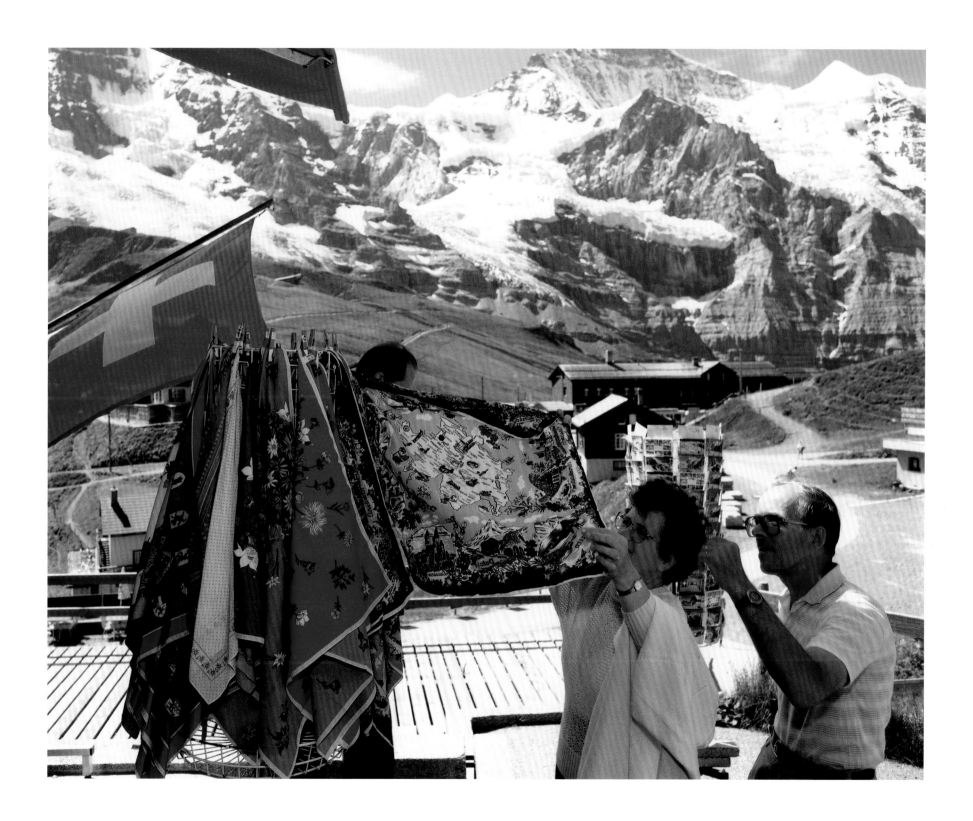

KLEINE SCHEIDEGG, SWITZERLAND

37

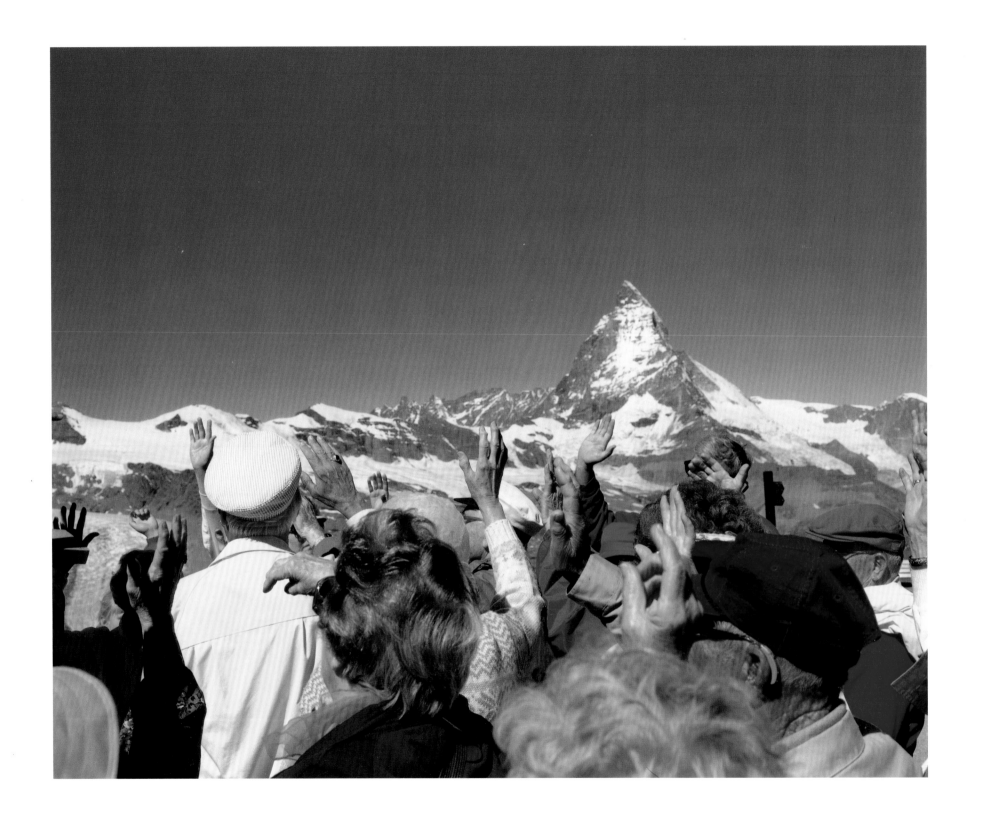

THE MATTERHORN, SWITZERLAND

38

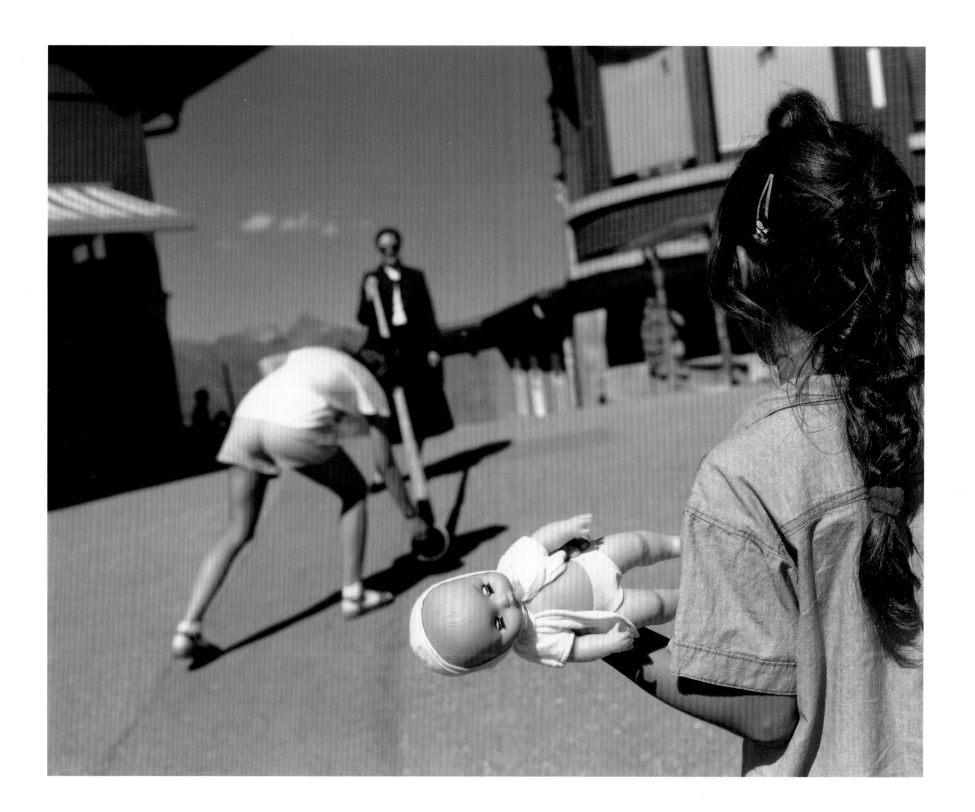

KLEINE SCHEIDEGG, SWITZERLAND

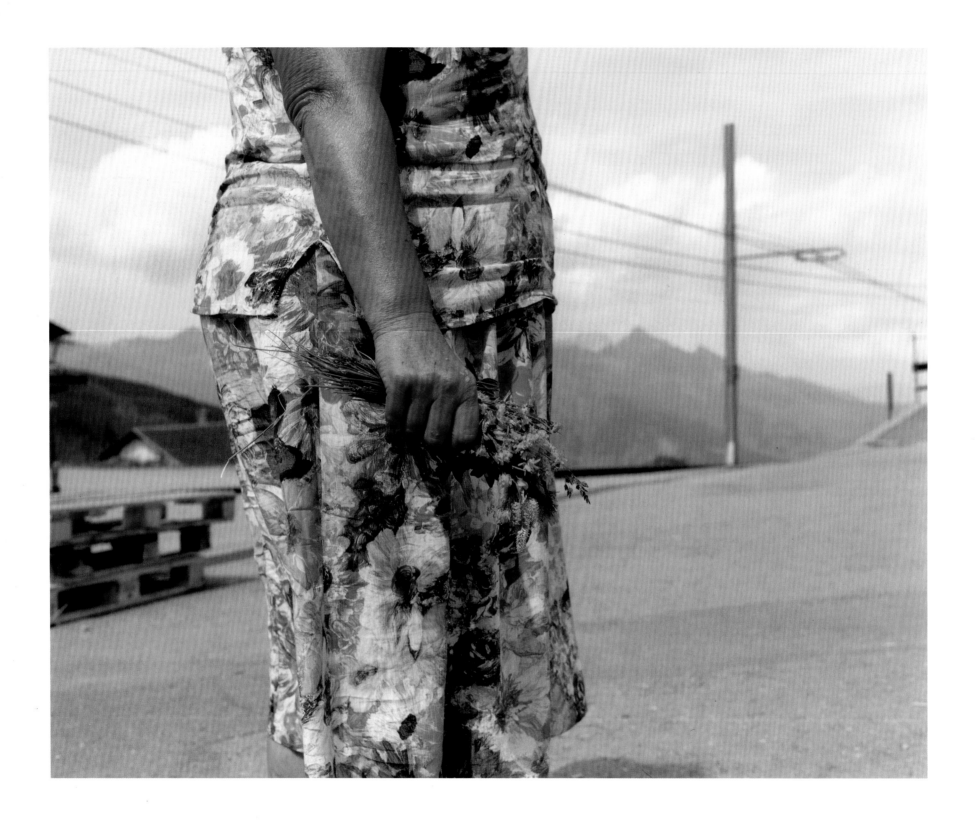

KLEINE SCHEIDEGG, SWITZERLAND

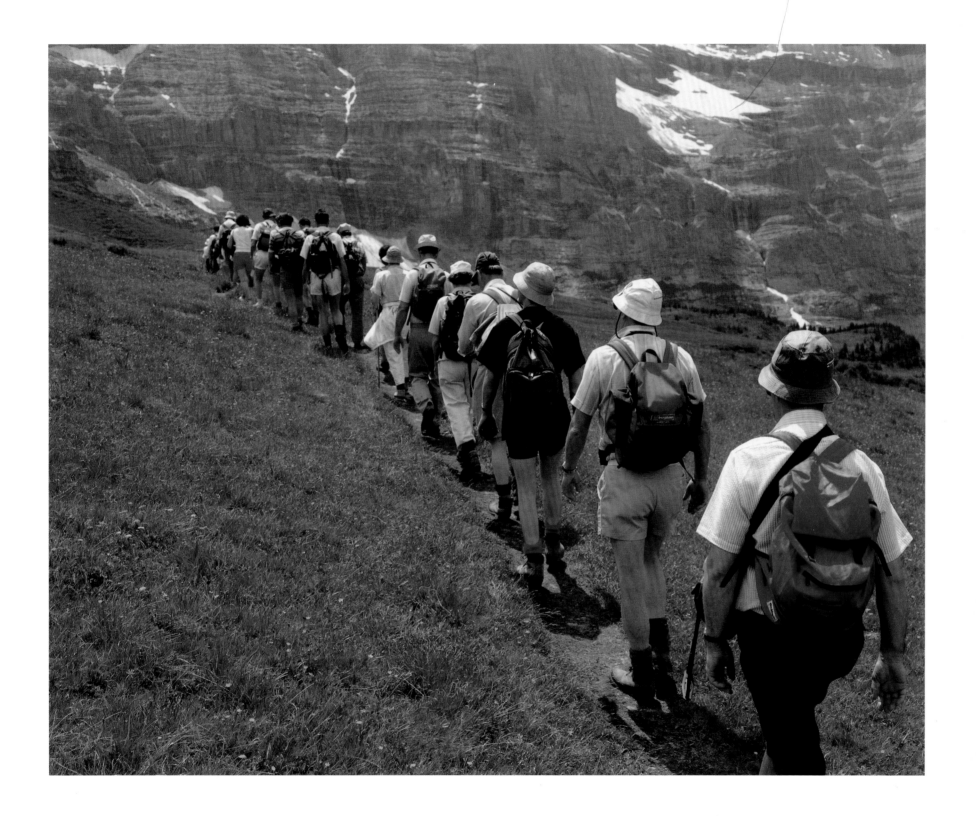

KLEINE SCHEIDEGG, SWITZERLAND

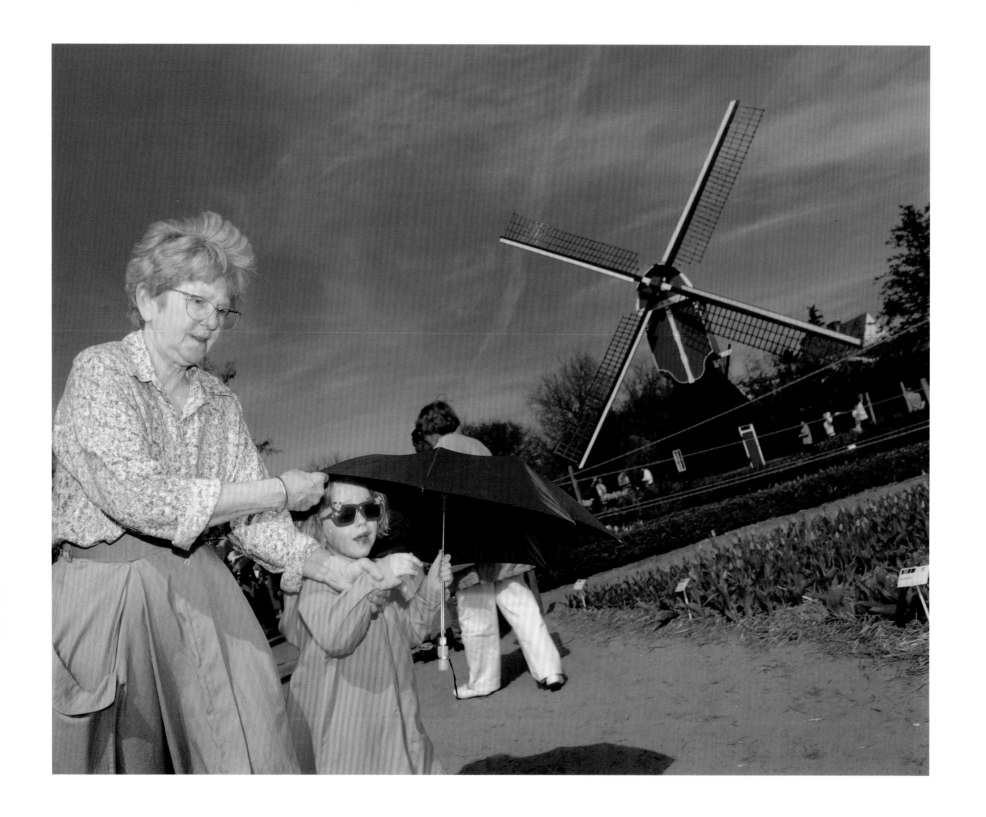

BULB NURSERY, HOLLAND

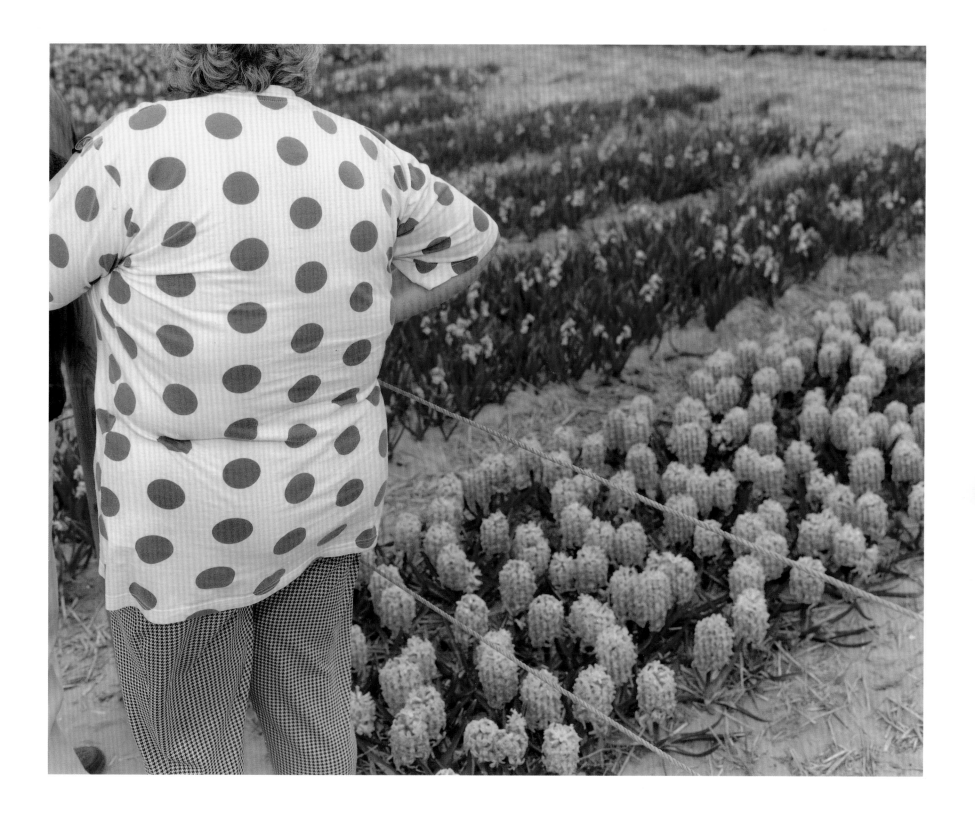

BULB NURSERY, HOLLAND

43

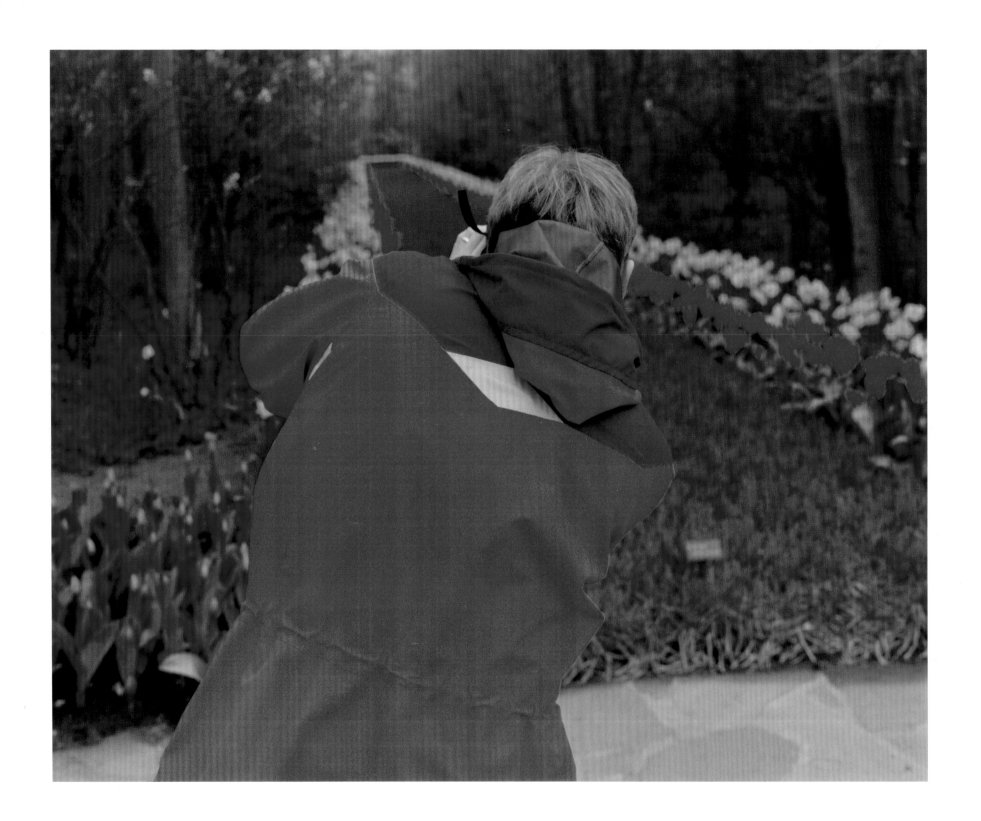

KEUKENHOF, HOLLAND

44

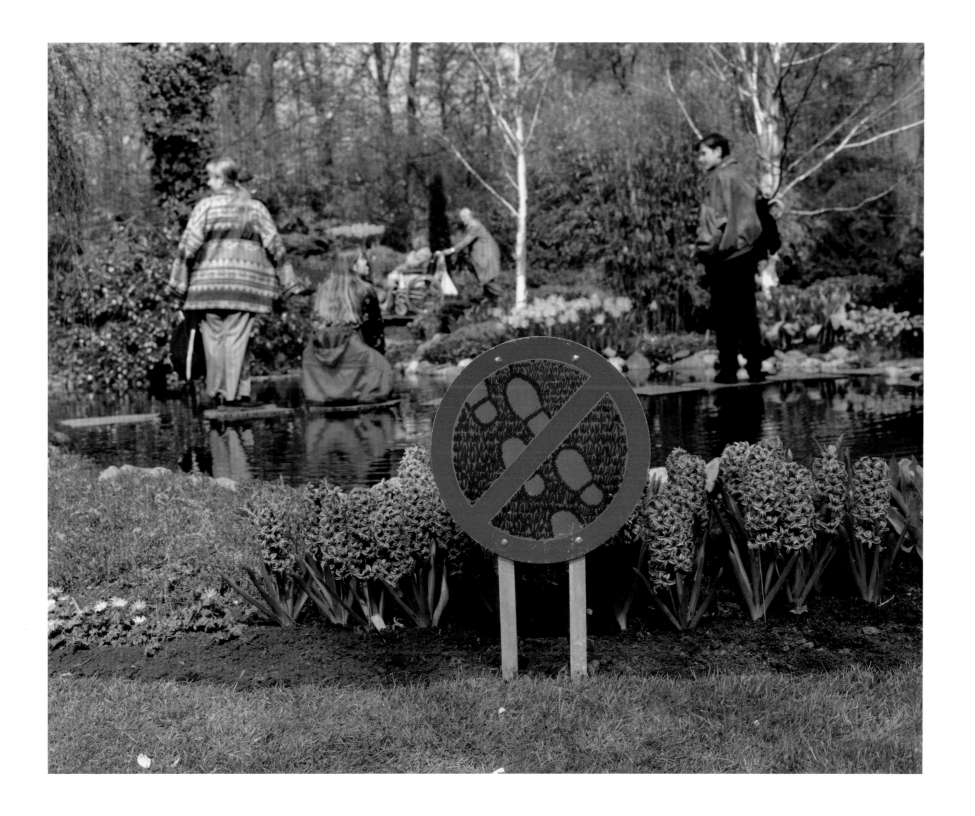

KEUKENHOF, HOLLAND

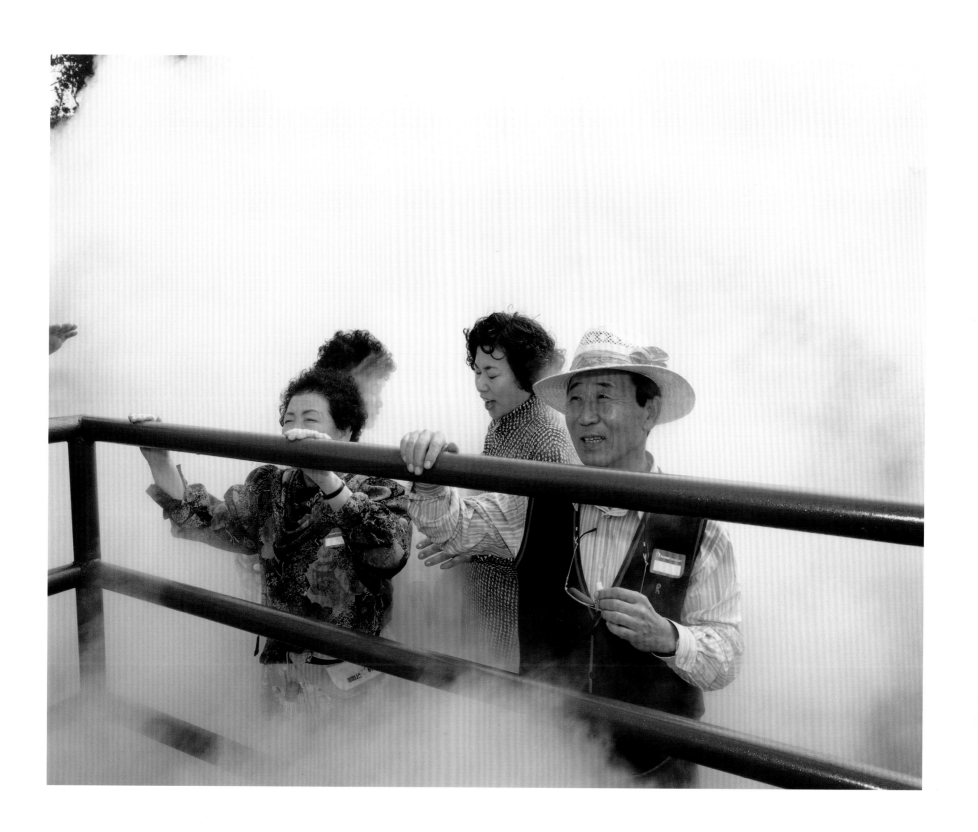

VOLCANO, BIG ISLAND, HAWAII

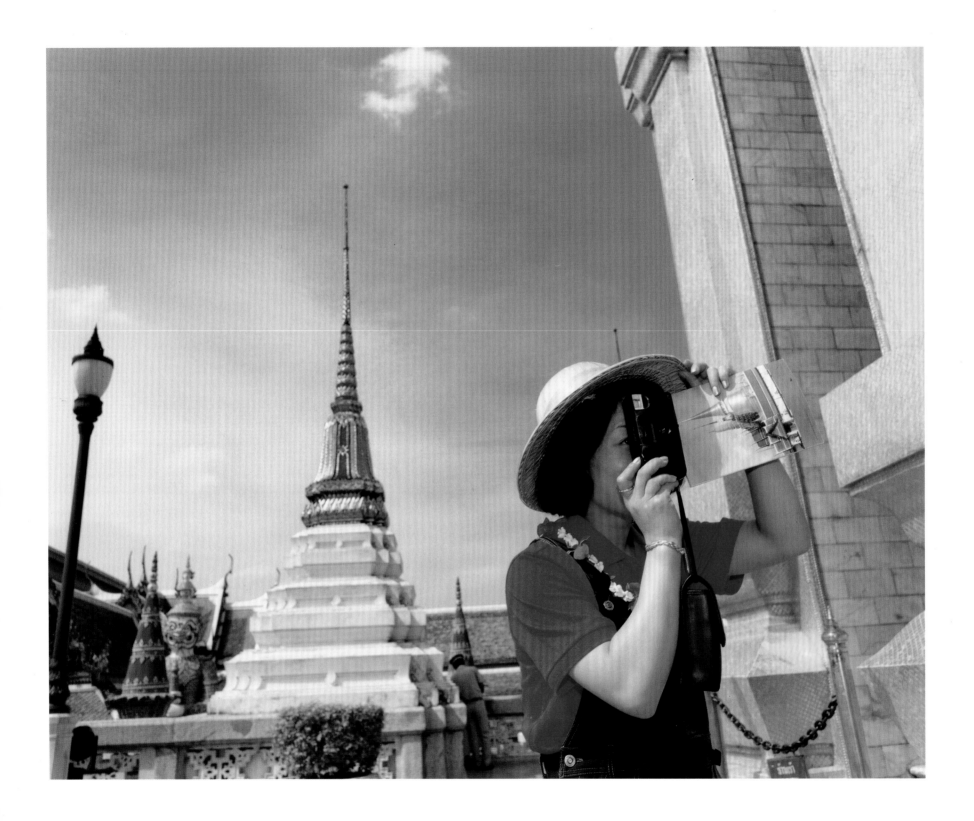

GOLDEN TEMPLE, BANGKOK, THAILAND

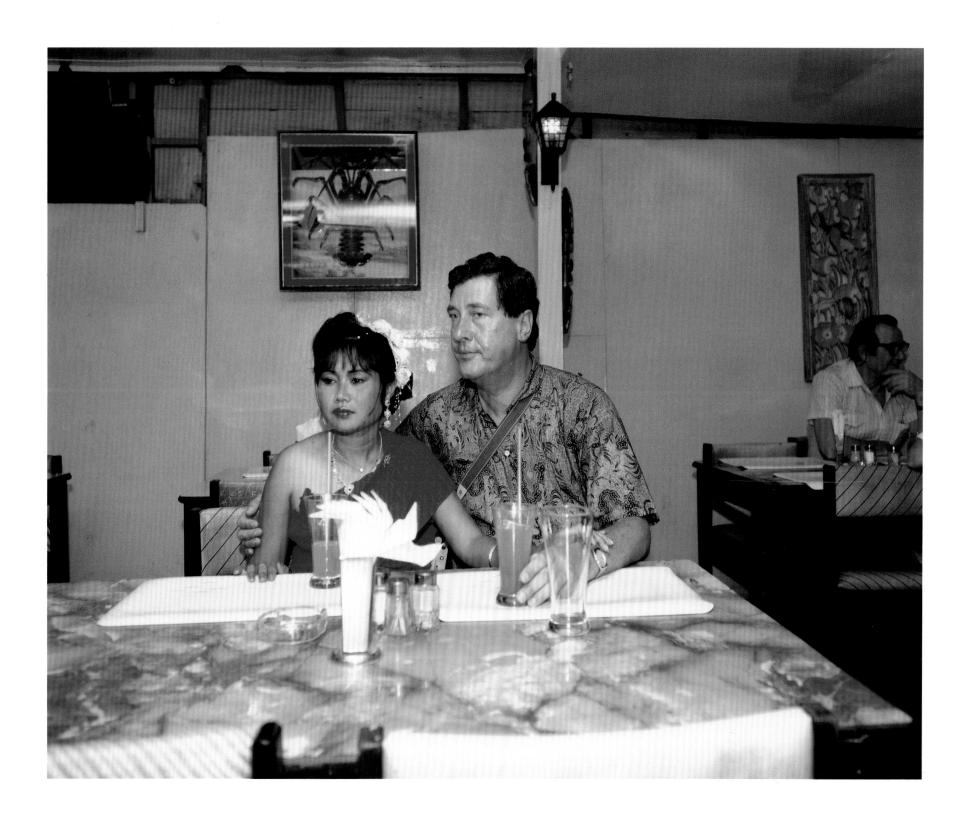

PATTAYA, THAILAND

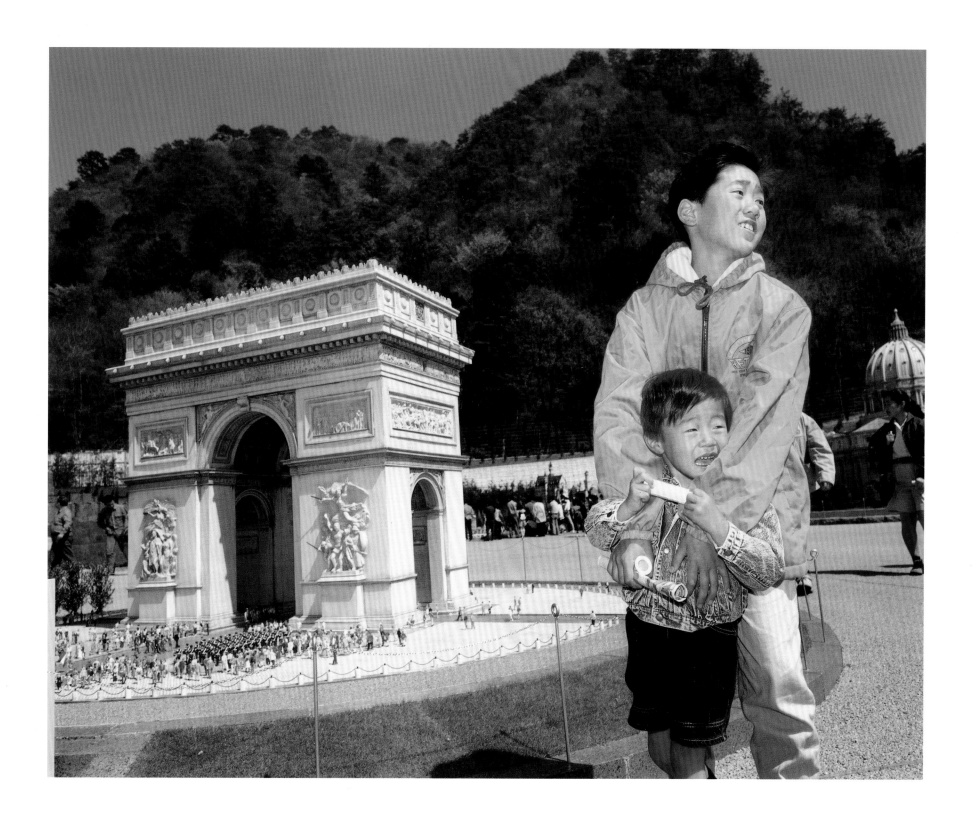

TOBU WORLD SQUARE, JAPAN

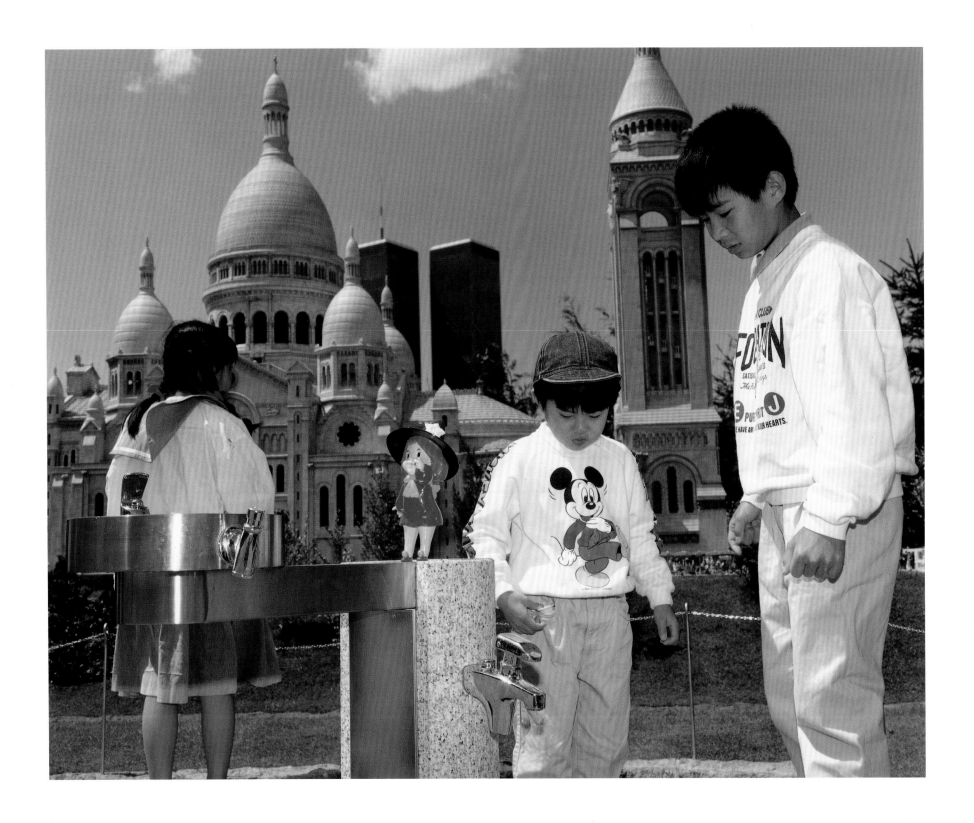

TOBU WORLD SQUARE, JAPAN

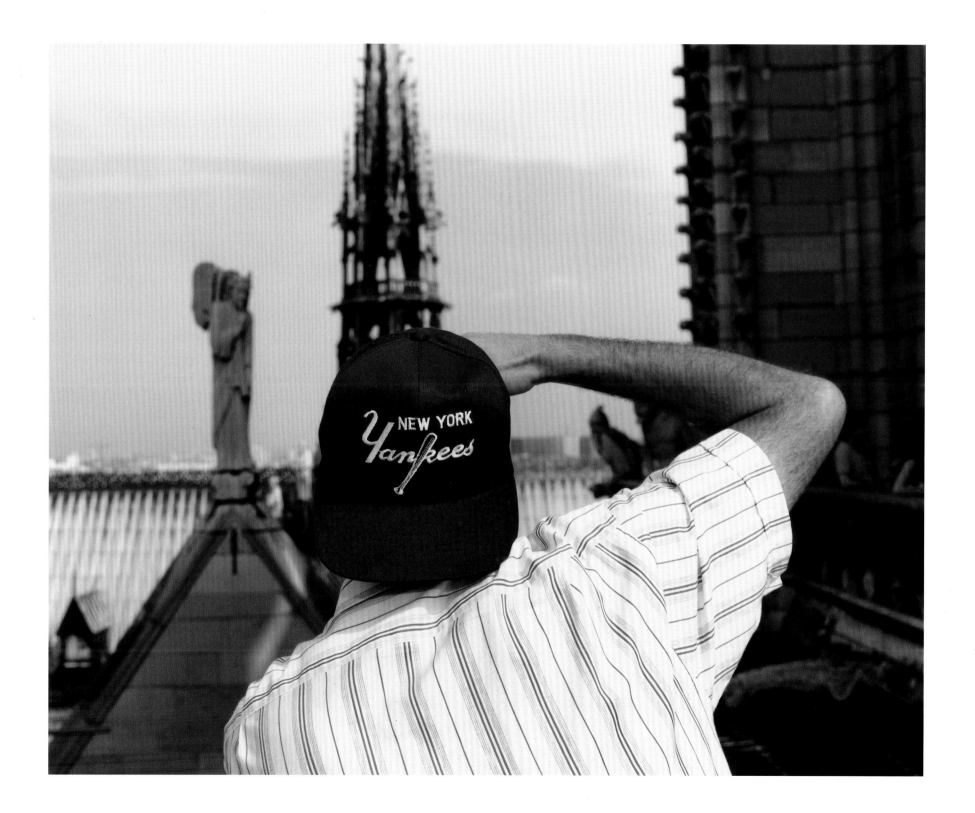

NOTRE DAME, PARIS, FRANCE

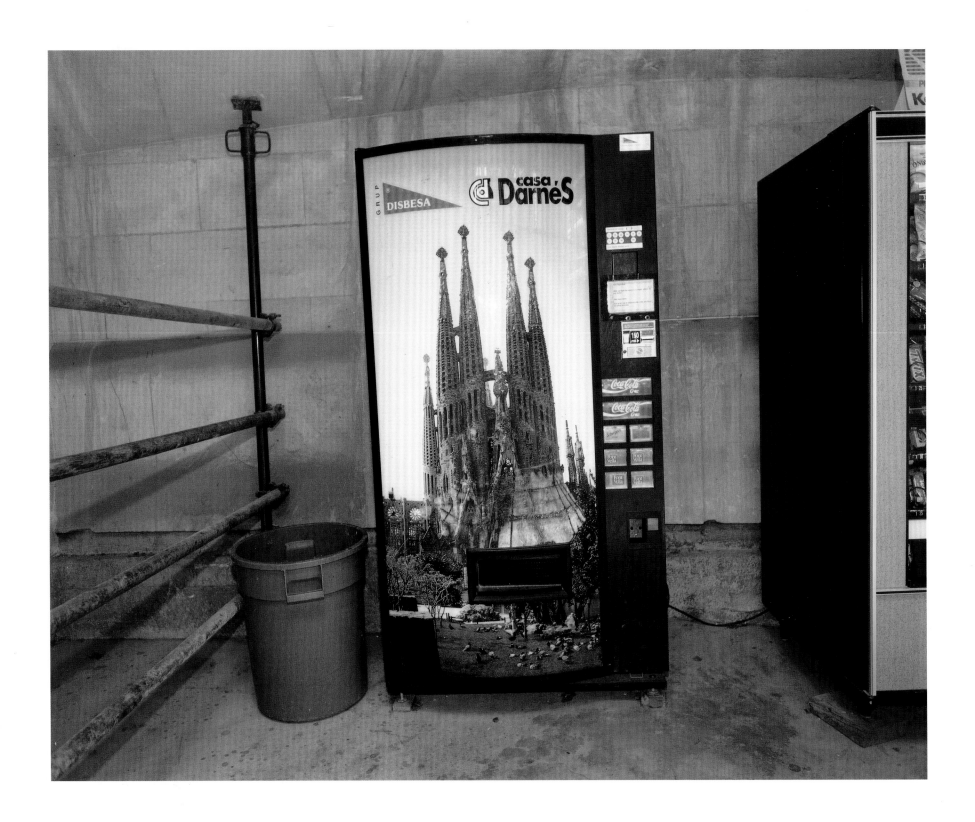

BARCELONA, SPAIN

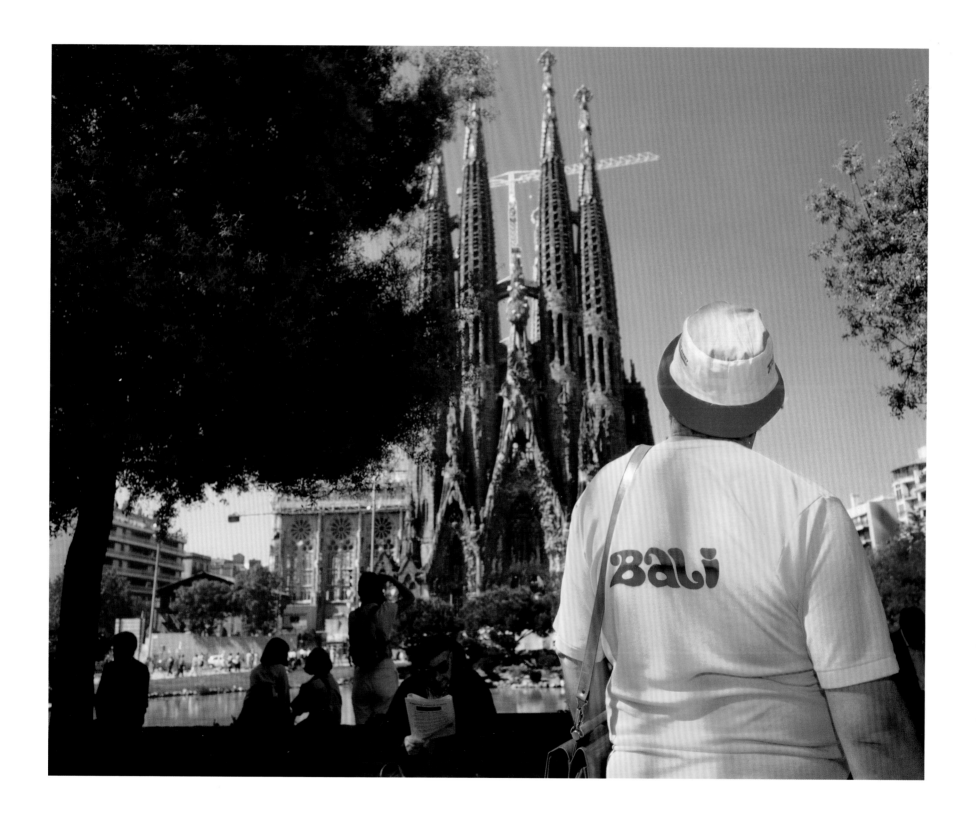

SAGRADA FAMILIA, BARCELONA, SPAIN

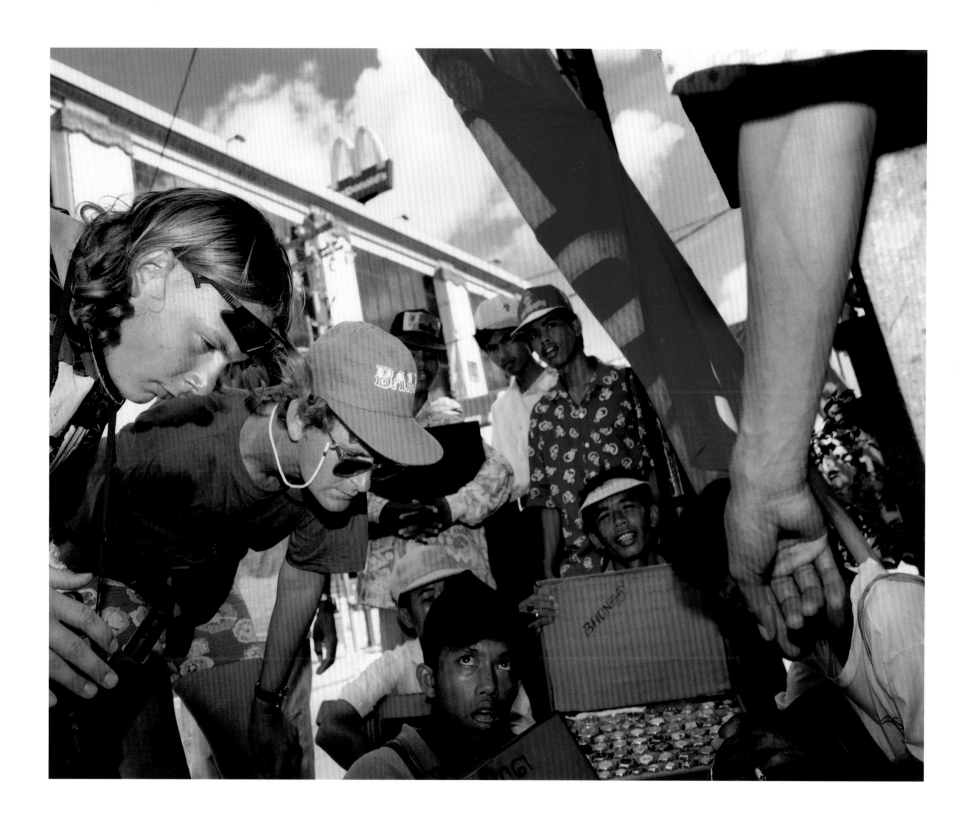

KUTA, BALI

54

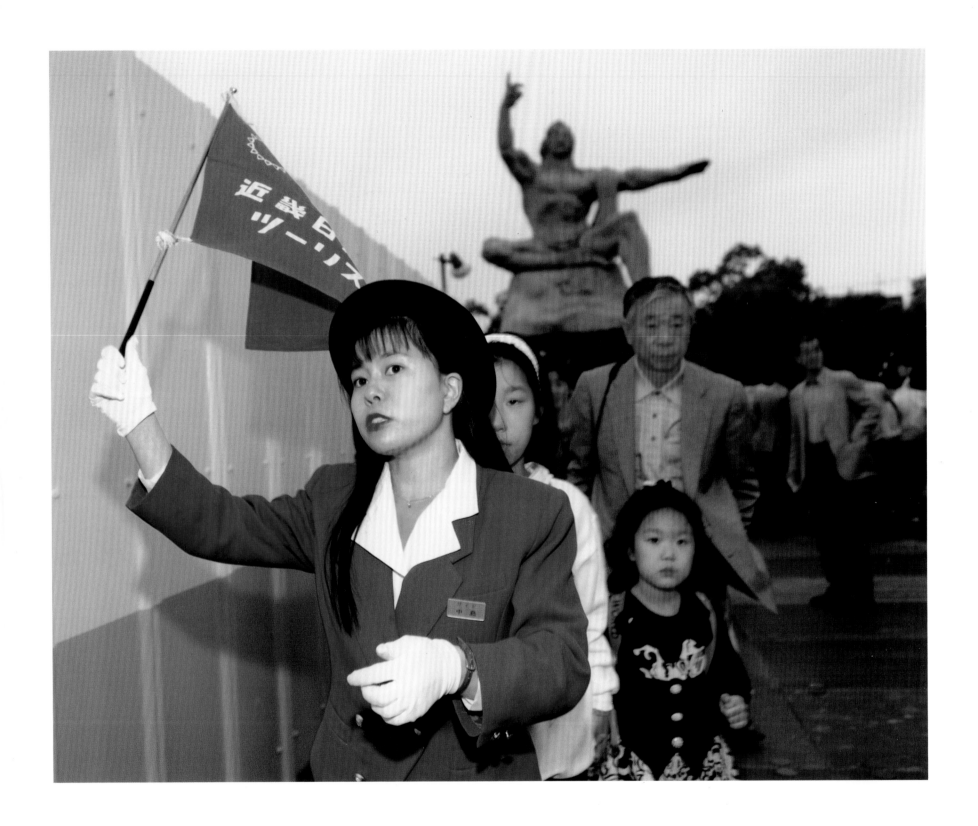

PEACE MEMORIAL, NAGASAKI, JAPAN

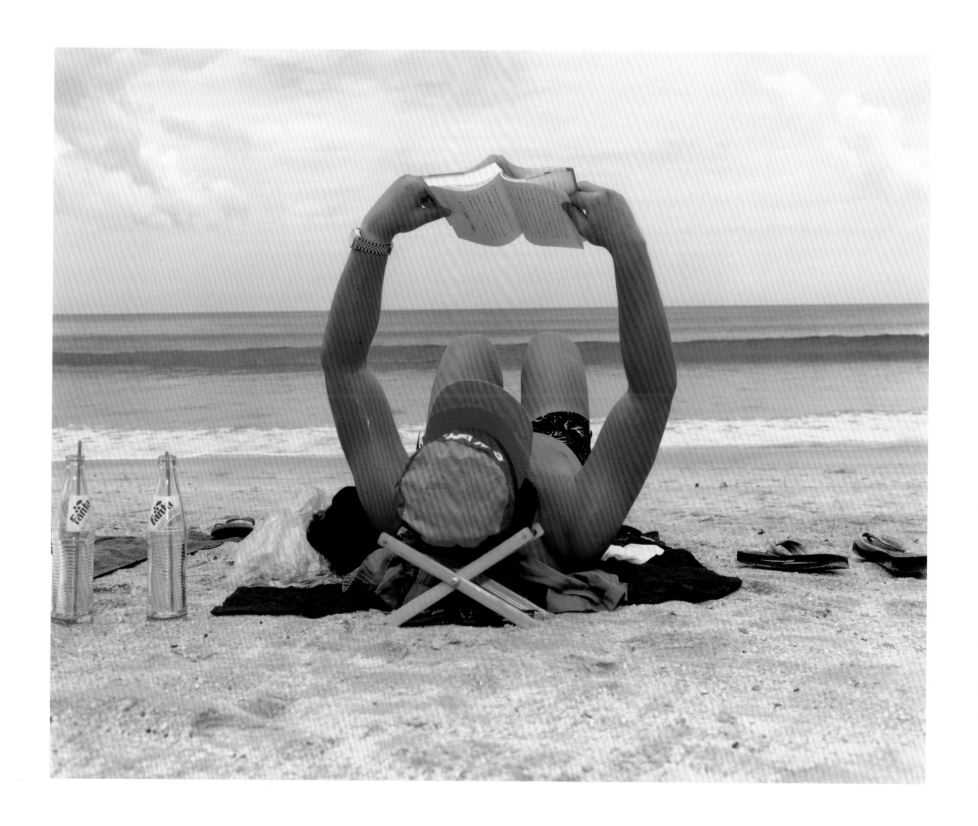

KUTA, BALI

56

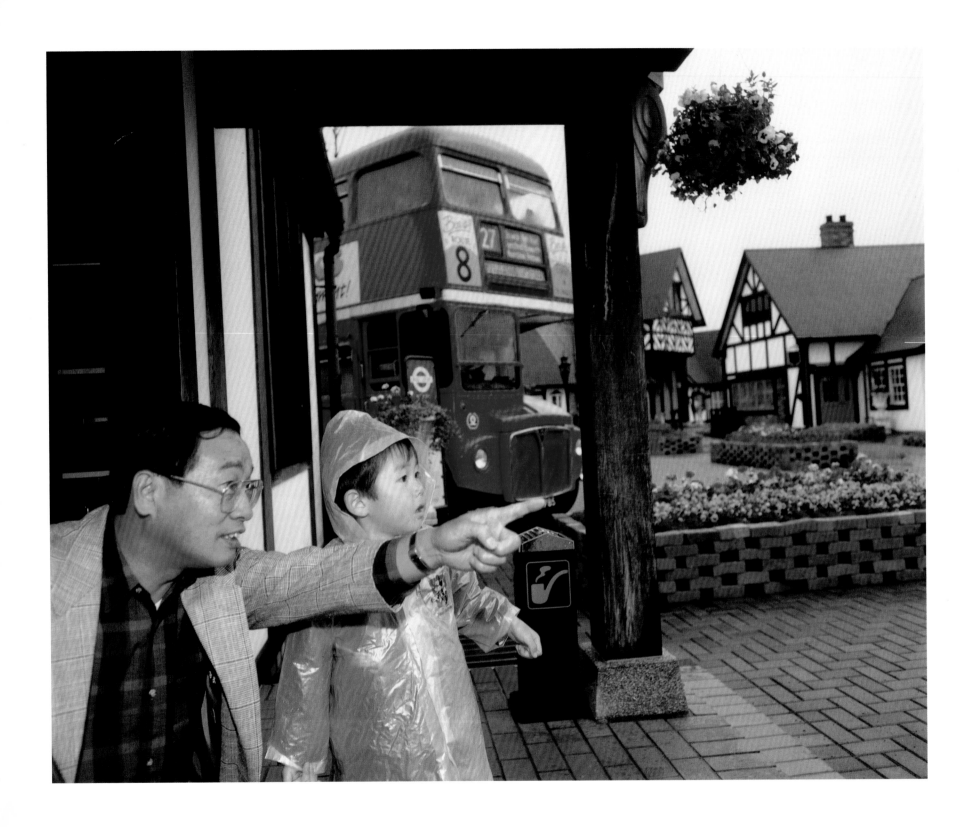

RAINBOW VILLAGE BRITISH THEME PARK, JAPAN

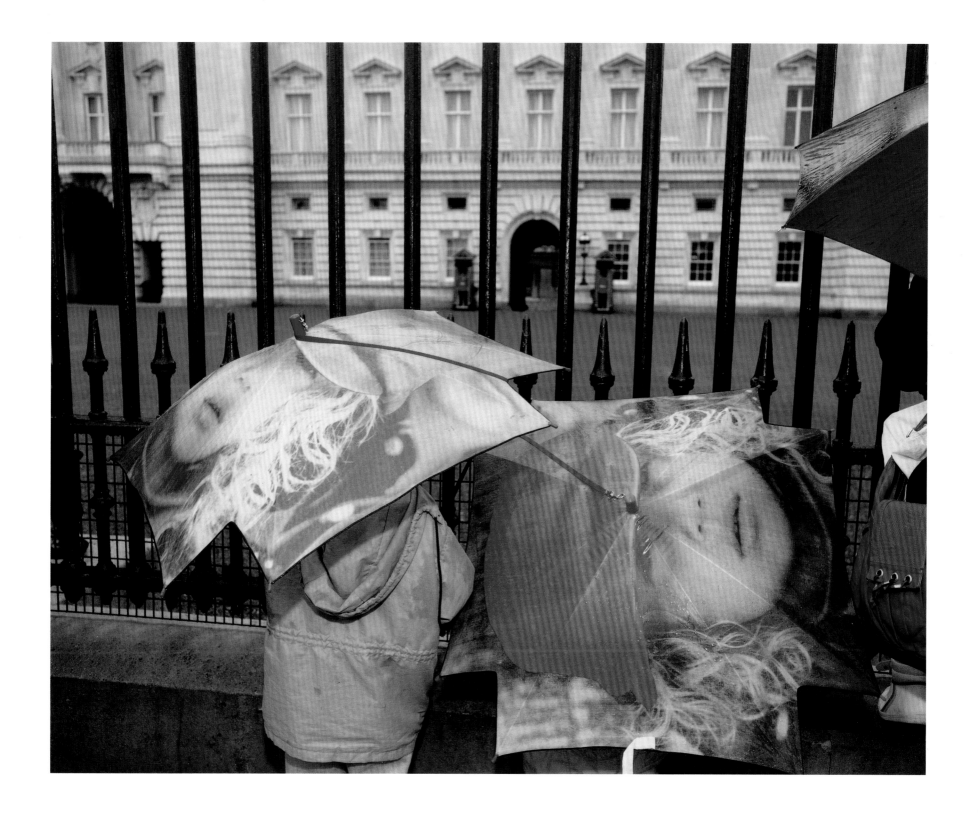

BUCKINGHAM PALACE, LONDON, GREAT BRITAIN

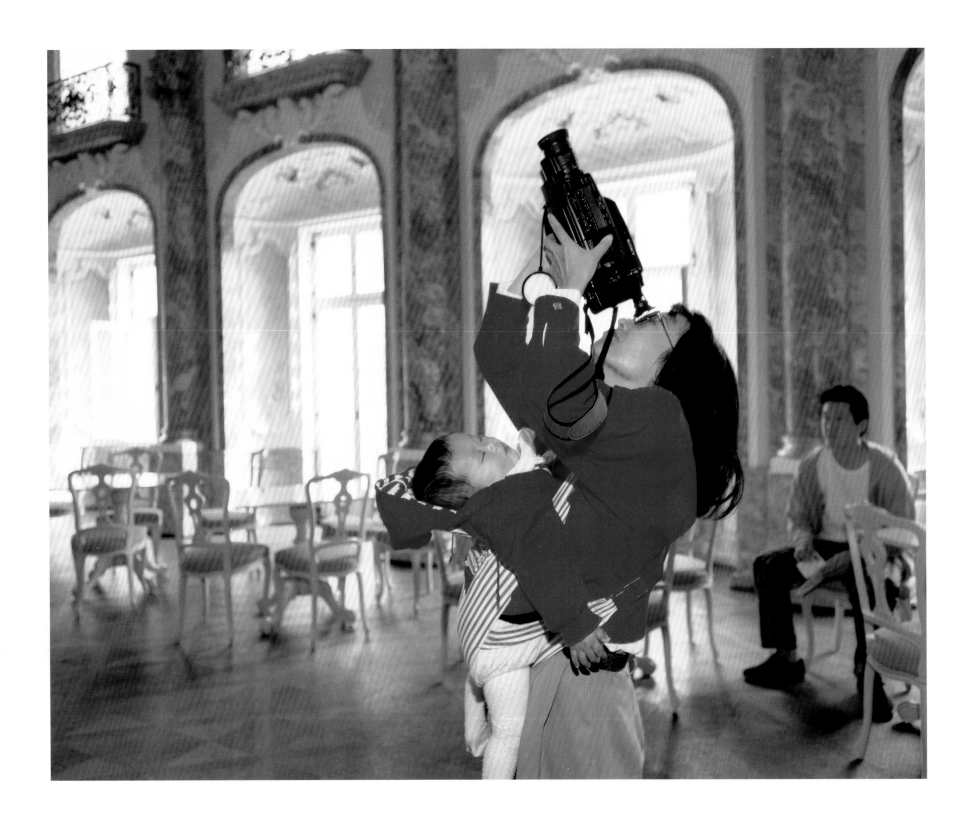

HAPPY KINGDOM GERMAN THEME PARK, JAPAN

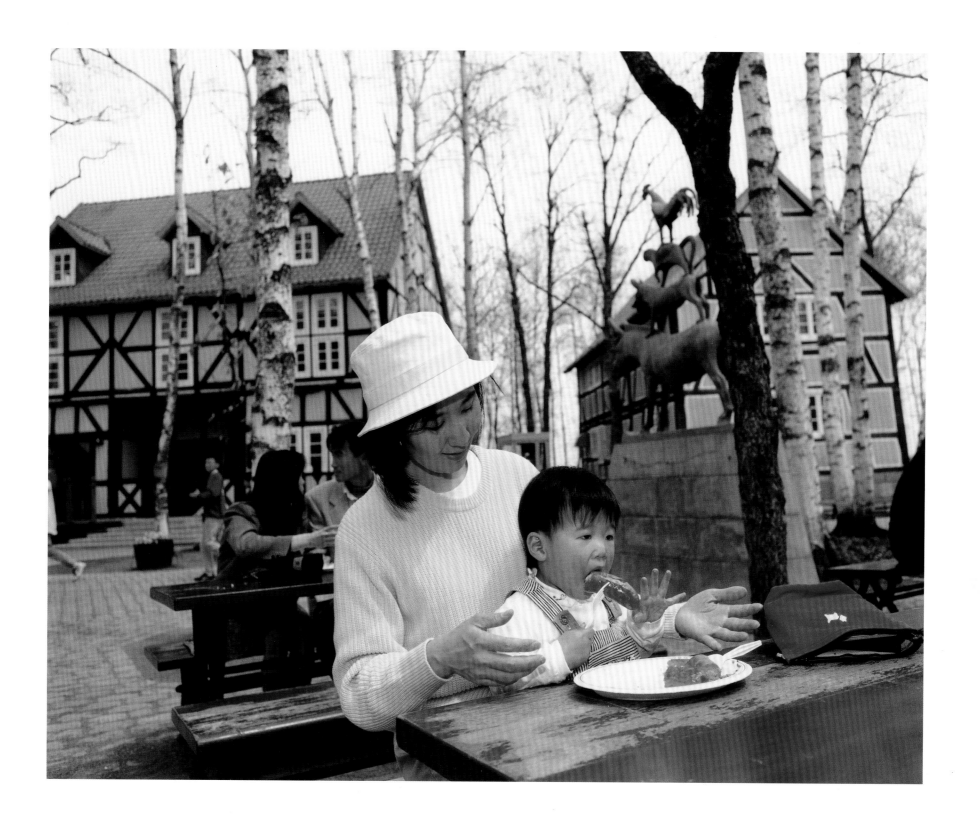

HAPPY KINGDOM GERMAN THEME PARK, JAPAN

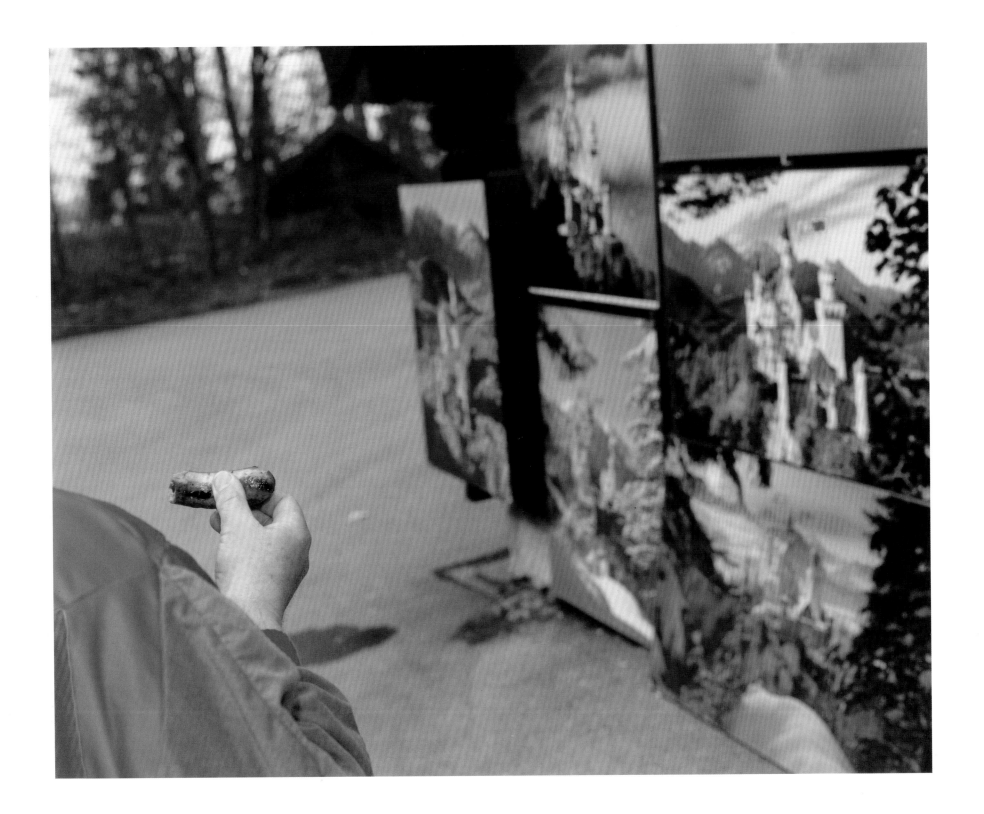

NEUSCHWANSTEIN, GERMANY

61

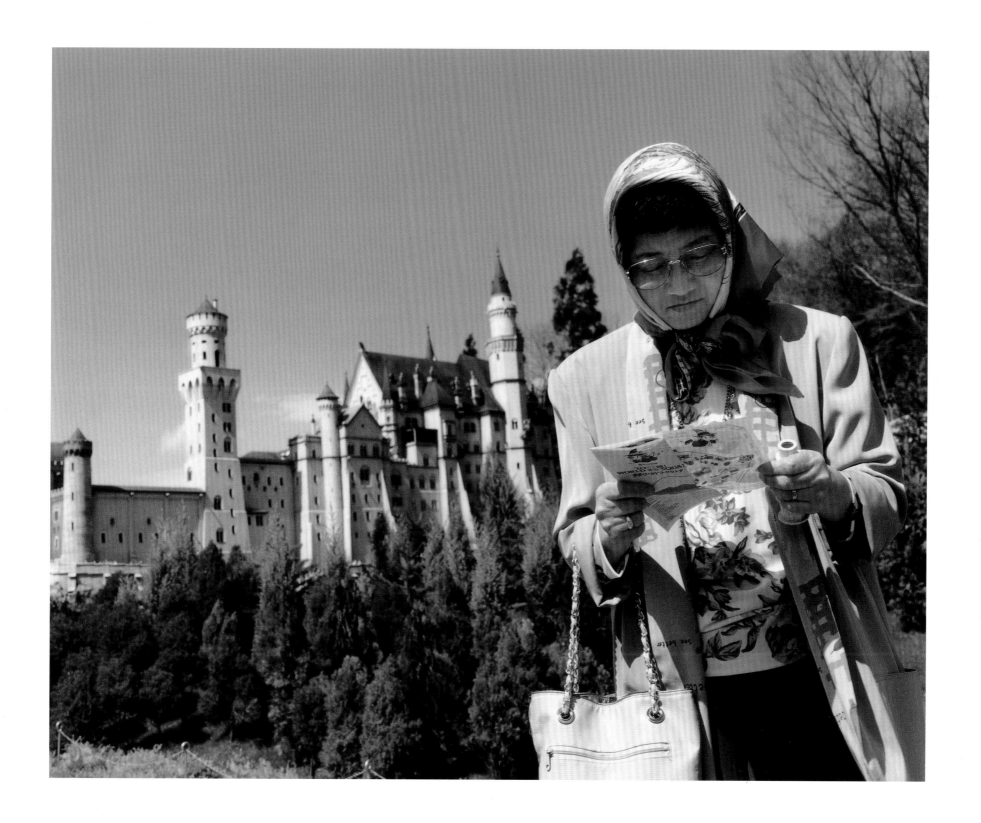

TOBU WORLD SQUARE, JAPAN

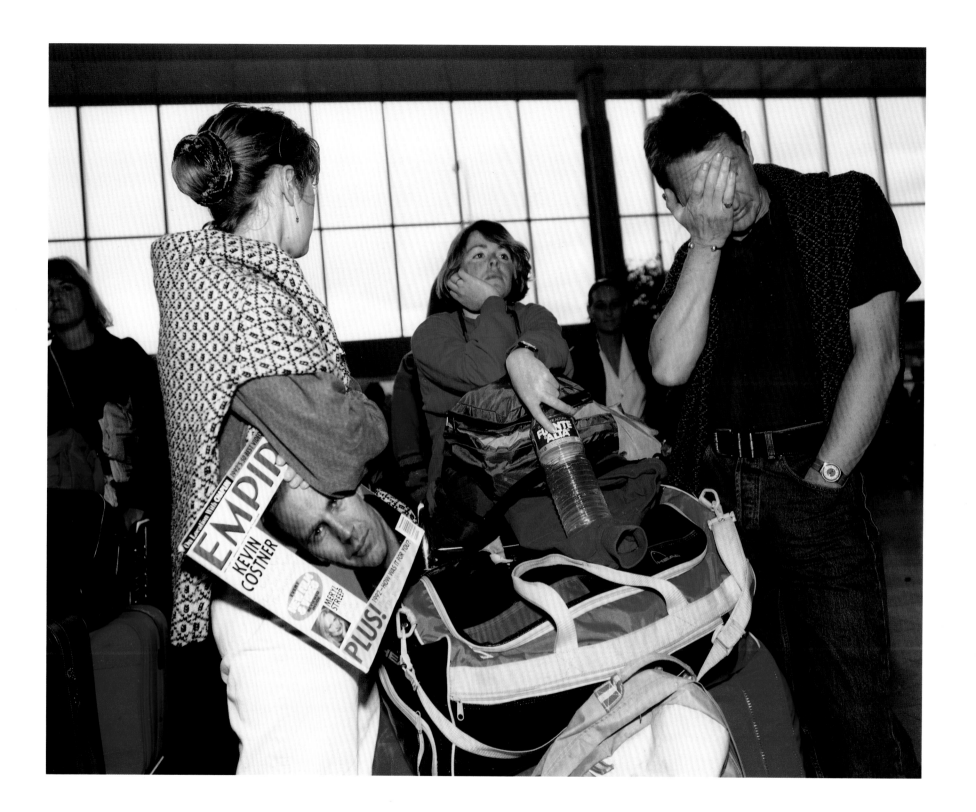

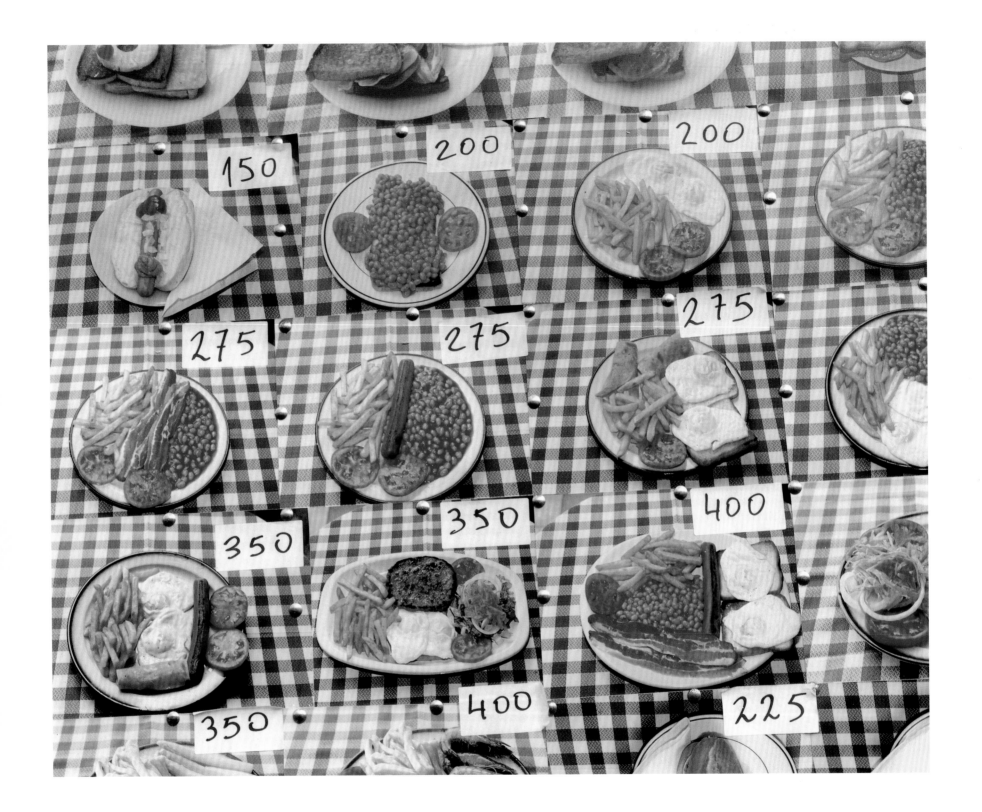

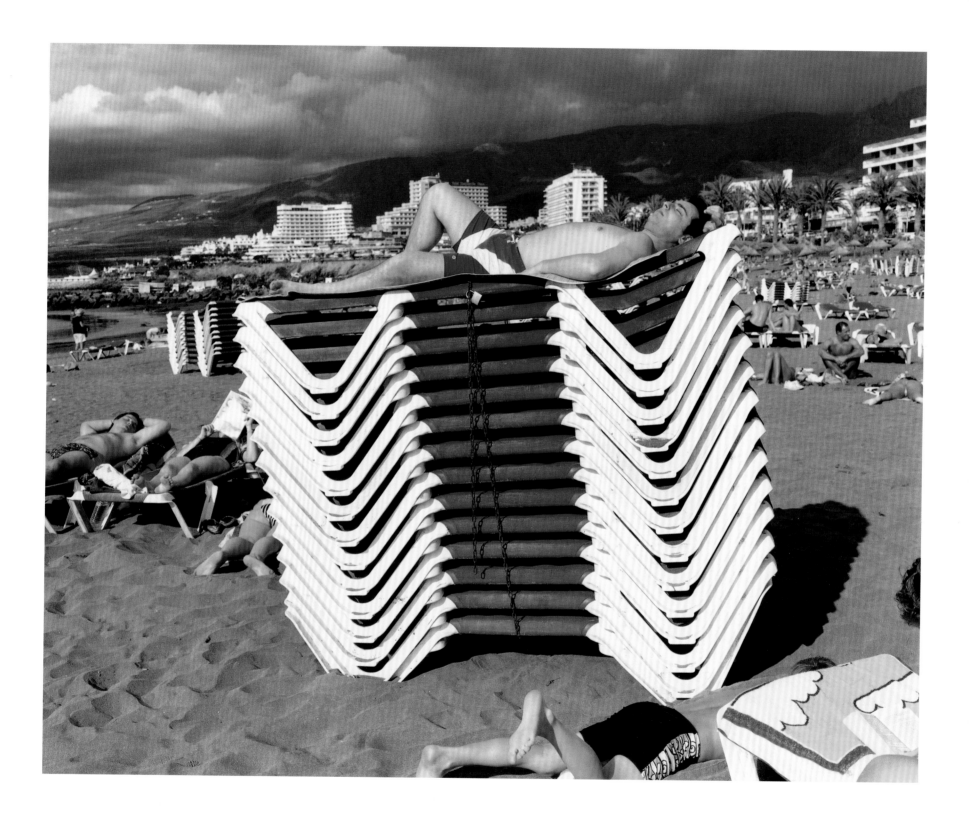

PLAYA DE LAS AMERICAS, TENERIFE

65

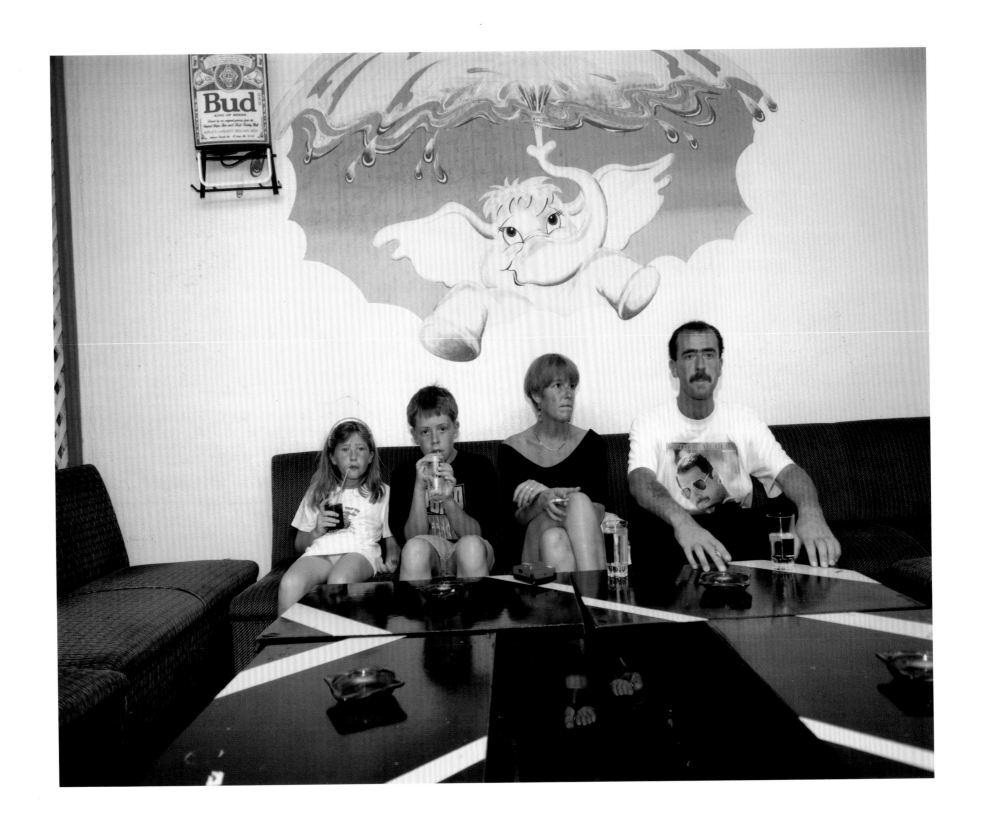

MAGALUF, MAJORCA

66

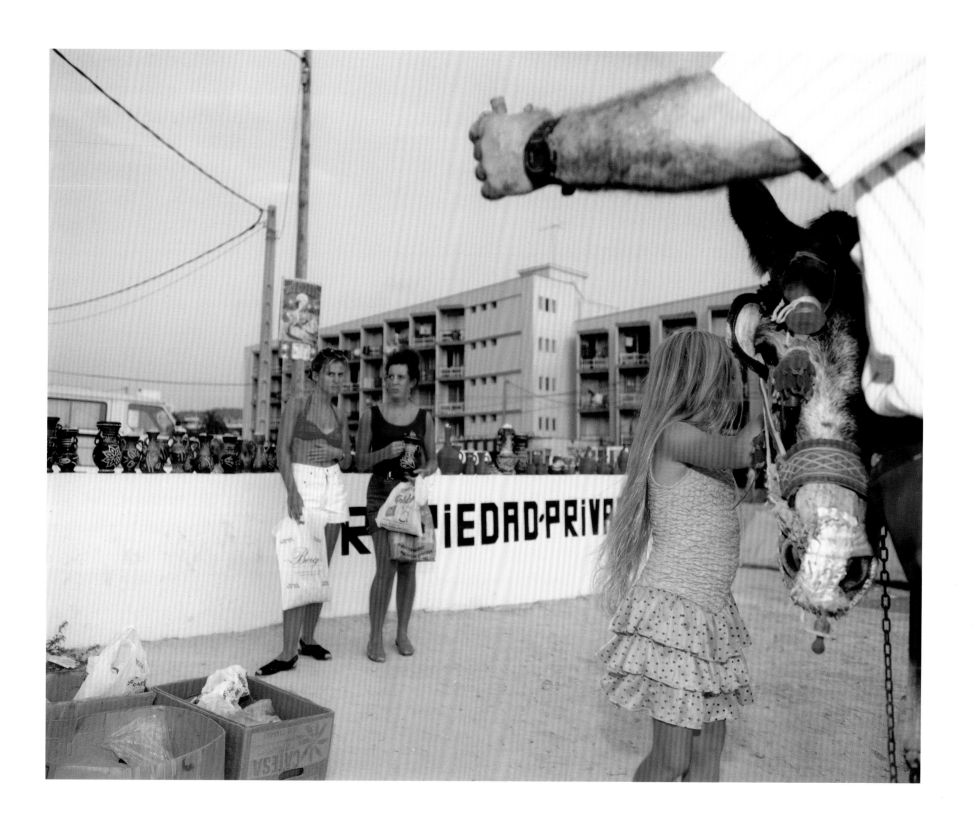

SANTA PONSA, MAJORCA

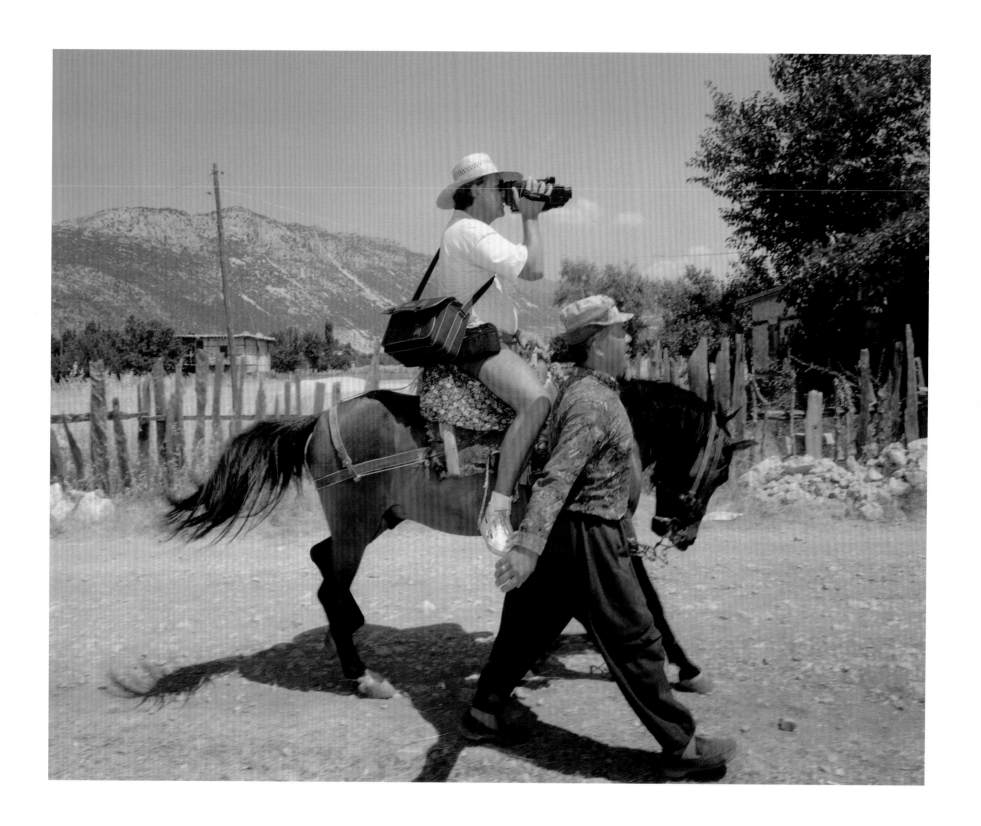

KALKAN, TURKEY

ACKNOWLEDGEMENTS

I would like to acknowledge the help and support of

Nick Barker

Chris Boot

Michael Collins

François Hebél

Susie Parr

Val Williams

Martin Parr, Magnum Photos

June 1995

Type C prints by Peter Fraser

Edited by Dewi Lewis

Designed by Alan Ward, Axis Design, Manchester

Reprographics by Leeds Photo Litho, Leeds

Printed in Italy by ProStampa Sud Grafica Editoriale, Rome

This book was set in FF Quadratt